Thayne-

I am so glad us so many years ago. I am grateful for you, your talents that you so graciously share with others, and your passion for Disney.

You are truly one of my favorite spirits in this world. ☺

xo-
Chasta

HANDLE
the HORRIBLE

HANDLE the HORRIBLE

Change. Triage. Joy.

CHASTA HAMILTON

HOUNDSTOOTH
PRESS

Handle the Horrible
Change. Triage. Joy

ISBN 978-1-5445-3433-6 Hardcover
 978-1-5445-3434-3 Paperback
 978-1-5445-3435-0 Ebook

FOR LOVERBOY, CHONKIS, AND KILLER.
HOLD MY HAND, ALWAYS.

CONTENTS

FOREWORD

HAVE YOU HEARD of Aesop's fable *The Crow and the Pitcher?*

Here's the gist:

The crow is extremely thirsty and has been diligently searching for water. He realizes that if he is not able to find water soon, he will die. Suddenly, he comes upon a pitcher containing water. Unfortunately, when he gets closer, he realizes the water is near the bottom of the pitcher, and he is not able to reach it. He looks around and wonders how he could possibly reach the water. He sees some pebbles piled underneath a tree. Suddenly, he drops a large pebble in the pitcher and notices that the water moves. He wonders, could he drop enough pebbles into the pitcher to raise the water level? He knows he has to try. He drops pebble after pebble into the pitcher. Slowly, the pitcher's water level rises. After many pebbles and a significant amount of time, he is able to reach the water and quench his thirst.

Perseverance.

What exactly is perseverance?

Merriam-Webster defines the word as the "continued effort to do or achieve something despite difficulties, failure, or opposition."

The crow certainly exhibits perseverance as he struggles to find water that he so desperately needs to survive. Many examples of perseverance exist throughout literature as well as history.

The following are two of my personal favorites:

> *Sir Winston Churchill, the prime minister of Great Britain, who, during the darkest hours of World War II, used his rousing speeches to urge the British to continue fighting against the Germans and to never give up. Great Britain, especially London, was enduring the relentless bombing of the German Luftwaffe, and there was very little hope for them to hold on to except for Churchill's encouraging words.*

> *During World War II, John F. Kennedy served as a young naval officer commanding PT-109. During routine patrol in the Pacific, a Japanese destroyer rammed his small PT boat. Although he was seriously injured, he returned to the wreckage of the small boat numerous times to rescue the remaining members of his crew from the waters of the Pacific, safely bringing them to shore.*

Although the above are well-known, historical instances of perseverance, there are a number of sources of inspiration that exist closer to home. These examples of perseverance are exhibited by people seemingly leading their everyday, ordinary lives. Oftentimes, these stories are never acknowledged or made public.

The author of this book, Chasta Hamilton, is no stranger to perseverance. Unfortunately, she learned to persevere when she was very young due to the loss of both her parents. First, she lost her father, and seven years later, she lost her mother after a hard-fought, two-year battle with breast cancer.

I am Cheryl Bueck, and biologically, I am Chasta's maternal aunt. However, the above unfortunate circumstances allowed me the opportunity to become her guardian and play a role in her upbringing. From the time she was nine, I had the pleasure of guiding and directing this fantastic and incredibly talented young lady into adulthood. Watching her grow and develop into the person she is today is my life's greatest achievement.

I've often wondered:

- Is perseverance taught or is it a learned experience?
- Or, is it simply acquired through observing people who exhibit the qualities of perseverance?

I am without the answer to either of those questions, but what I have observed in life is that some people seem to possess and display the trait while others do not.

Maybe we will find the answers to these questions within the pages of this book.

Cheryl T. Bueck

PROLOGUE

> *"You gotta resurrect the deep pain within you and give it a place to live that's not within your body. Let it live in art. Let it live in writing. Let it live in music. Let it be devoured by building brighter connections. Your body is not a coffin for pain to be buried in. Put it somewhere else."*

—EHIME ORA

TWO YEARS AFTER I was born, a book was released titled *Alexander and the Terrible, Horrible, No Good, Very Bad Day.* Alexander romps through a comedy of errors of really annoying and unfortunate circumstances that plague his day. As a child, I would sit in my grandpa's lap amused at the story, wondering if any actual person's day could be this derailed.

A cockeyed optimist from a very early age, I adamantly believed in packed-out days of fun and creativity. I couldn't understand that the ending of this book was simply, "Mom says some days are like that."

And then I became an adult...

There were twelve days left in 2021. It was cold, dreary, and ominous. A panicked tension hung over the world. When I stepped out our front door wearing my sunglasses on a cloudy and stormy day, my husband, John, looked at me and said, "Are you feeling optimistic, or are you going to need to hide some tears today?"

Deflated, I solemnly said, "I'm just trying to keep the dream alive."

Earlier that week, the up-tempo sounds of a pop version of "It's the Most Wonderful Time of the Year" pushed through my office door. When I looked in the dance studio room, I saw happy, energized, smiling dancers dressed in holiday festive headbands, sweaters, and necklaces. I was even wearing a whimsical Christmas light necklace for "Light It Up Day!" as I forced an aura of merriment and solidarity through waves of sporadic tears. It was my first holiday season as a mom and my second holiday season as a small business owner in a pandemic. The Omicron variant was picking up the pace, and nobody seemed confident in what was happening next.

Professionally, I am an entrepreneur. Stage Door Dance Productions is the heart of my work. With two locations, an average of eighteen staff members, hundreds of dancers each season, and thousands of dancers served to date, we believe in empowering and inspiring children through the performing arts. Our buildings are bright, happy places where sunshine permeates to the depths of our souls. Personally, the studios are my passion and calling. I've learned to hustle

hard and use my voice to elevate my business, brand, and life mission. There is no glory without the grind. My tenacity can often be misinterpreted as difficult, but I prefer to view it as determined.

This attitude of determination has gotten me to where I am today. Along the way, I've also been repeatedly thrown into the arena of change management. Business is not for the weak, and neither is life. A determined fighter, I'm used to juggling strategy sessions, emails, attorney and accountant calls, and now, my son's desire to have lots of fun, all the time. When anxiety seeps in, or a knot forms in my throat, or in the pit of my stomach, his innocent squeals ground the chaos and remind me that leadership is paramount. It's bigger than me. I am rooted and grounded in my duty to deliver optimism to not only my child, but to the children and people we interact with every single day.

Twenty-two months into a global pandemic that wreaked worldwide havoc, it wasn't easy. There was resistance, fatigue, challengers, and exhaustion. Everyone had grown accustomed to sitting in their anxiety, and I was trying to leverage my anxiety into success. I had not worked this hard, for this long, to watch everything I had built crumble like a haphazardly pulled puzzle piece of a Jenga tower.

On one of the blurry, dreary days of the holiday week, a student dropped a smiley, snowman-themed paper plate covered in wax paper on my desk. It contained delicious, homemade Oreo truffles. On the "from" line, there were parentheses after the student's name, exclaiming: (Your Enthusiasm Buddy!). This student was my enthusiasm buddy—passionate, ready

to go all in at any given moment, and openly transparent about the ebbs and flows of her emotions during this wildly unpredictable time. I couldn't help but smile as I thought about one of my memories from the year.

Months earlier, in late April of 2021, I sat quietly on the stool in the corner of the pale pink and green room we affectionately call Studio 3 at Stage Door Dance Productions. I watched dance after dance perform in one of the final rehearsals in preparation for what had originally been intended as our 2020 Benefit Show. It was canceled in March 2020, along with pretty much everything else in the world, because of the COVID-19 pandemic.

At the time, I was thirty-nine weeks pregnant, due on May 4, and most people would suggest that I shouldn't be at the rehearsal. But, after three weeks of preterm labor, my doctor had given me an encouraging go ahead to enjoy the final days of pregnancy by "relaxing and having fun."

For me, that meant being with my people and being in the thick of this show. I wasn't about to miss our return to the stage.

We were living in a time where shows weren't happening. Professional stages were quiet. No Broadway. No regional theater. No ballet. No symphony.

One day, this may seem unfathomable, but we lived it.

For our studio community, we kept the idea of performance alive through performing outdoors or in our parking lots as often as possible. It never duplicated the actual experience or energy of having an active audience. But, it worked as a temporary solution and it kept our community safe and going.

It had been four-hundred-plus days since we performed for an audience, and the excitement was mounting for our 2020/2021 Benefit Show. It would be performed in the Raleigh Little Theater Amphitheater to a scaled back audience of two hundred.

There was a time where performing to that small of an audience in a venue that holds three thousand might have felt offensive or been deemed silly. In this new era, it seemed incredibly exciting and familiar; something we had all been longing to experience after months of being isolated in our houses and confined to our computer screens. The thought of being back on stage gave me chills.

As the rehearsal concluded, I asked the dancers to sit down.

Looking around the room, I felt an invisible weight of heaviness. We'd been carrying it for months. The state of the world was taking its toll on everyone, and it was time to refresh our perspective.

I jumped up, feeling way more energized than I anticipated. It was as if a spiritual calling consumed my body in the message I was about to relay to this pre-teen crowd.

> *Dancers, you did this. You waited, worked, persevered, and maintained your craft. You kept your focus on causes larger than yourself and are doing something that will allow people to leave their houses and enjoy live arts; something they may not have experienced since early 2020. This is magic. YOU are magical. And let us never lose sight or take for granted the power we have in our ability to perform. Because through performance, we live, and we have a lot of living to do!*

Holding back tears, I finished, nodded in agreement with myself, and looked around the room.

It seemed like spirits might be lifting, ever so slightly.

In the back corner, I noticed a dancer starting to weep.

Shocked, I gently asked, "Are you crying?"

The student, my aforementioned Oreo truffle-loving, enthusiasm buddy, elevated to sobs, proclaiming it was the wisest, most moving talk she had ever heard.

The heaviness lifted, giving way to electric energy. That energy carried all the way through the show weekend. In that cathartic moment, I realized I had not only inspired my audience, I inspired myself.

I released bottled-up energy that represented this ever-mounting fear that we might lose everything we had known: our arts, our ability to perform, the opportunity to connect, and the ability to experience catharsis that helps us process, understand, and survive trauma.

Art is a passion; it's a push to guide our survival through whatever is happening in our lives and in the world. When life gets derailed, the process of performing has the power to help get us back on track.

During the pandemic, we all experienced a collective crisis that challenged every system and infrastructure of society.

Healthcare. Education. Childcare. Mental Health. Business. Capitalism. Government. Finance. Race Relations. Gender Relations. Global Relations.

The crisis and its correlating, systemic issues started impacting us in March 2020. It was still impacting everyone at the end of 2021 and had impressively carried itself well into 2022. Each phase had its own set of unique challenges.

Many seized the opportunity to reset and reform, questioning how we could do better in our respective work and lives. Others sat in complacency, failing those around them.

We watched, we waited, and we did what we could to keep some type of semblance to our pre-pandemic lives intact.

We weren't experiencing mild irritants like accidentally dumping a grande skinny caramel macchiato on your white sundress on your way to an opening night or losing your beloved sunglasses in the ocean in Cancun. Trust me, I know those kinds of irritants, too. This was a core-shaking, rock-your-world kind of shift that makes you freeze in fear or pivot towards perseverance.

This was a time where we simultaneously lost and discovered life.

In my world, I experienced the best and worst of people. I watched my businesses nearly collapse, had a miscarriage, experienced a full-term pregnancy, and added motherhood to the list of my roles.

This constant change reminded me that nothing is guaranteed. Control is a facade. The way we choose to respond and navigate the challenges placed in front of us matters.

The pandemic was not the first period of time where I experienced cataclysmic shifts in my life. You might have read a bit about some of them in my first book, *Trash the Trophies*, which details my decision to remove my dance studios from the toxic environment of the competitive dance industry. This was a radically risky move that turned out to be one of the best, most strategic decisions I've ever made. The heart of the book transcends competitive dance as it delves into my journey of transformative leadership.

That story was only the tip of the iceberg of the amount of change I've experienced and endured.

Through each experience, the cycles seem to have a pattern:

- Fail

- Figure It Out

- Recover

- Heal

After thirty-six years, I feel confident in saying this is the rhythm of my life. If there was a metronome keeping the beat, this pattern would set the tempo. Sometimes, the cycle moves fast, like a petit allegro in ballet class with complex, whipping footwork. Sometimes, like now, the cycle is drawn out and prolonged, like a musical that added a few too many ballads in act two. Regardless of pace, all of it, the highs, the lows, the fast, the slow, and everything in between, have made me into the person I am today.

During 2020 and 2021 I took that rhythmic tempo to the most intense level I've experienced. And there was a huge, differentiating factor: in every other crisis, the arts existed in all of their varying, wondrous states. Our passions could be freely practiced. There were outlets where we could release our stress and heal. An afternoon at the movies or an evening at a show offered community and exciting conversations about what we loved, hated, and looked forward to seeing next. Now, all of that was gone, and we were relegated to our screens and devices with mismatched Zoom audio and one too many solemn, concert performances of "Smile."

During this period of time, my daily thoughts included:

- When the arts have the power to heal and are simultaneously put on pause, how do you have the tenacity to recover?

- When your career is compromised because of questionable, blanket policies that shutter the doors of your business for months on end, how do you keep moving?

- When everyone is scared and confused and has no idea what's happening, how do you lead in a way that is comforting, consistent, and calm?

- How do you keep some semblance of art alive to offer a healthy outlet to your community?

- When the breakdown happens in its varying forms, how do you respond?

Dr. Maria Rosario Jackson, Chair of the National Endowment for the Arts, said it best when she stated, "I deeply believe that we are all at our best when we have art-filled lives. And that we can't, as a nation, reach our full potential without the arts."

After writing my first book, I was amazed at the positive response to my story. It was released in August 2020. At the time, I wasn't confident people would read it, but the process had been so cathartic that it didn't really matter. As the feedback slowly but steadily rolled in from around the world, I felt comforted in the fact that people resonated with my very real experiences and conflicted journey surrounding competitive dance. In sharing a peek into my truth, I was healing myself and simultaneously inspiring others.

I felt layers begin to fall away as I realized that chaos, crisis,

and change are recurring themes in my life. I can sit and function in an unforgiving cycle of disruption.

I don't enjoy it. But I am able to manage it.

In this current climate of the world, that seems to be a necessity for survival.

Instead of operating in constant crisis, I'm learning to function alongside crisis. Much like the "service engine soon" light on your car that pops up at truly the most inconvenient times, chaos, crisis, and change are often unpredictable and swoop in without warning. They're the terrible things that happen on a beautifully sunny day, or the darkness that seeps into a twinkling holiday season. They're the topics we often don't wish to discuss but need to discuss in order to process and heal. They drain us when we lack the fuel to even feel drained.

In being conscious of ourselves and our response to crises, we can learn to live in and focus on the beauty, temperance, and seasonality of life, knowing that "this too shall pass."

In the early 2000s, I binged a few boxed DVD sets of *Grey's Anatomy*. If I thought Alexander knew how to have a bad day, Meredith Grey really knew how to have a bad day. With this show, the drama of the voiceovers, the music ("Chasing Cars," come on), and the utter states of constant crises were captivating. In fact, if you read the "Quotes" section I've preserved on my Facebook like a nostalgic moment in Mark Zuckerberg's "college students only" era of the platform, you'll find a few Meredith Grey quotes.

During the pandemic, I started rewatching *Grey's* and fell back into the rabbit hole of my "old friends" and their drama. Somehow, it seems like there's always a quote to match the

moment, onscreen and in real life. While writing this book, this quote from McDreamy resonated:

> *"If there's a crisis, you don't freeze, you move*
> *forward. You get the rest of us to move forward*
> *because you've seen worse, you've survived worse,*
> *and you know we'll survive, too. You say you're*
> *all dark and twisty. That's not a flaw; that's a*
> *strength."*

—DEREK SHEPHERD, SEASON 5, EPISODE 19

There was a point around Season 6 when I wondered, *How much of a crisis can one person endure?*

I've had the same thought about my life.

There was a time when I didn't talk about the challenges I've faced. I felt stronger, more courageous, and more equal when I kept them to myself. I felt as though I could work harder and stay more committed on a more "normalized" playing field with my peers. But in holding that information in, I was holding myself back.

Zig Ziglar said it best when he noted, "F-E-A-R has two meanings: 'Forget Everything And Run' or 'Face Everything and Rise.' The choice is yours."

My choice is to rise.

After the past few years, I've realized a huge part of rising is owning your truth, sharing the experience, and inspiring others in the process. When that happens, we rise, and we rise together.

The following things have gifted me the grit to handle it all:

- Support

- Time

- Wisdom

- Love

- Inspiration

- The Arts

The first few things on this list are a given. We universally recognize the importance of a support system and love. We know that wisdom comes with experience, and time can ease the pain. But, I didn't realize the inspiration I discovered through the arts saved me in many ways until the pandemic offered an extended period of time to sit, think, reflect, and remember.

Simply put, the arts are a place where you can lose and find yourself at the exact same time. Through creation, we listen. And as we listen, we learn. Through stories, we view the world and ourselves through the lens of others. Through that process, we gain insight, conviction, and strength. We heal.

During one really tumultuous period of time, my best friend, now husband, John, sent me the song "Scars" by Alesso featuring Ryan Tedder because it reminded him of me.

When I received that song, I felt loved.

After I opened my first dance studio, my aunt sent me a card that played the Phil Collins song from *Tarzan*, "You'll Be In My Heart." When I opened the card, I felt supported.

In early 2017, I bought Cheryl Strayed's *Brave Enough* at Anthropologie. As my world crumbled around me, I read the powerful quotes and felt empowered and seen.

During a reflective moment in 2019, I listened to Lady

Gaga sing "Grigio Girls." When she longed for answers for purpose and sense, I felt heard.

In early 2022, when I sat in the audience of *The Music Man* and felt this exuberant energy pour off the stage from Hugh Jackman, Sutton Foster, and the cast, I felt joyful and energized.

All these instances affirm the power of art to connect us with others through beautiful mediums that speak to the shaking, soul-discovering purpose of our existence.

In seeing ourselves in pieces of performance and art, we become closer and more confident in our organic selves. It can be a book, a play, a film, a song, a quote, or a dance that inspires us. The medium doesn't matter as much as the message. When we learn who we are through our circle of people, the mistakes we make, the inspiration we find, and the experiences we share, it all plays a part in developing our sense of self.

The acting, the falsities, the need for societal affirmation and acceptance strip away as we slowly but surely step into our power. This usually happens while being challenged and getting knocked down. Hakuna matata sounds ideal, but is it realistic? This confidence is much more of a mechanical bull ride instead of an ascension to a throne. It's a journey, not an arrival, and it is most certainly not a destination.

This level of self-awareness helps us better prepare for the moments when other people and their experiences impact, influence, and disrupt our ecosystems.

The work, and this cycle, never ends.

But the art is always there. It guides us not only in our instinct to survive but in our quest for heightened, enlightened purpose. With every difficulty I can remember, I also think of a

movie, book, dance, song, poem, painting, or artistic experience that helped guide the way.

This level of catharsis through art is why I chose to plant my career firmly in the realm of arts entrepreneurship. I knew I could use the way the arts saved me to support my people, my community, and my personal and professional path. When you experience the unthinkable, you become more confident in the possibilities of life, and you want to share those possibilities with others.

One day during some kind of pandemic madness, I was having a conversation with my aunt about passion and purpose.

She looked at me and said, "Not everyone has self-actualized."

Confused, I stared at her.

She continued, "You know, Maslow's Hierarchy of Needs." [1]

I didn't know what she was referencing, so I headed straight to Google.

The pyramid represents the needs we must meet to have a fulfilled life.

In order of ascension (bottom to top), they are:

1. **PHYSIOLOGICAL.** These are the biological things we have to have to stay alive: air, food, drink, shelter, warmth, clothing, and sleep.

2. **SAFETY.** We thrive when we have order, predictability, and a sense of control.

3. **LOVE AND BELONGINGNESS.** We need strong interpersonal relationships and groups that generate belonging.

1 Saul McCleod, "Maslow's Hierarchy of Needs," SimplyPsychology, published 2007, updated April 4th, 2022, https://www.simplypsychology.org/maslow.html.

4. **ESTEEM.** We have to value our self-worth, accomplishment, and respect, and we also desire to receive this sense of reputation and respect from others.

5. **SELF-ACTUALIZATION.** This is where we realize our potential and self-fulfillment as we seek personal growth and peak experiences.

Depending on whatever the dish du jour of life presents on any given day, the hierarchy levels can fluctuate. It has been a long, winding road to think that maybe I have sensed feelings of self-actualization at points in my life. But no one teaches you to know these things. You have to guess. You go with the gut. And, if there's one thing I know from a life lived in crazy, the gut never lies.

During the pandemic, when the stages went dark, and I could no longer share my passion through traditional choreography and performance, I immediately started pushing that energy to two other passions: writing and speaking. The stories poured out of me as I acknowledged the inner turmoil, hardship, disruption, challenges, and obstacles I've encountered in this wild and beautiful opportunity of life.

In fact, when I was selected as a TEDx speaker at North Carolina State University in spring 2021, I pitched a talk about perseverance.

I had over twenty broad themes on the list. Here are a few:

- Death
- Disruption
- Divorce

- Miscarriage

- Betrayal

- Business Struggles

- Imposter Syndrome

- Mental Health

My speech curator looked at me and said, "We'll never fit all of this into an eighteen-minute talk. Pick a few." So I did, and the talk was titled, "You Weren't Built to Break." As I rehearsed this talk to the point of hearing it in my sleep, it resurrected other memories; moments I felt needed to be shared. They are here, in the pages of this book.

There's no doubt that success is a by-product of survival. Heartache and difficulties have shaped the production that is my life. The presence of the arts has infused inspiration and beauty in the best and worst of times. It may sound bohemian, but my life wouldn't be what it is without the combination of the two.

In college, I took multiple classes about the works of Shakespeare. While I wouldn't call myself a Shakespearean scholar by any stretch, there were moments in the text that had staying power.

One of those is from the play *As You Like It*. It begins:

> *All the world's a stage,*
>
> *And all the men and women merely players;*
>
> *They have their exits and their entrances,*
>
> *And one man in his time plays many parts…*

Theater is all around. We see it in politics, religion, business transactions, and day-to-day dealings. Our life is a play, and depending on the day, we may be the protagonist or antagonist in any given story, be it our own or someone's else's.

This text is my story, and I hope it will motivate and inspire your survival story.

It is divided into four parts.

In Part 1, Chapters 1 and 2 offer a glimmer of insight into who I am. Chapter 1: Dark Days reflects on my most difficult leadership days to date. Chapter 2: A Place to Fit In and Stand Out details the origin of my passion, purpose, and drive. A unifying theme in both is that through pain we can find positivity.

In Part 2, Chapters 3–6 delve into the logistics of our narratives, challenging if we can categorize the high concepts of our everyday life. Chapter 3: The Roles We Play tackles the many labels we carry as identifying factors in our sense of self. Chapter 4: The Breakdown discusses conflict identification. Chapter 5: The Build Up reminds us that the hardships only last for so long. Chapter 6: Stage Management questions how we keep it all going.

In Part 3, Chapters 7–12 capture a snapshot of the evolving world around us and how we choose to respond. Chapter 7: Changing Casts focuses on the people who come and go in our lives and how we process those transitions. Chapter 8: Scene Change notes how the world around us evolves. Chapter 9: Audience and Chapter 10: Reviews look at the way others view, observe, and critique our lives. Chapter 11: Scripts considers the direction we take as we manage the hurdles of life. Chapter 12: Curtain Calls recognizes the fact that every ending is a beginning.

In Part 4, Chapter 13 offers an Encore, a reminder to rev up and face the future with excitement. The Epilogue reminds us not to ignore or overlook mega moments that might be missed.

This book is here to remind you that yes, you can, even when you feel like you cannot. It's a love letter for the people who feel like they are the only ones. The leaders who sit alone in their difficult decisions. The life circumstances that isolate us from tradition. The societal labels that wreak havoc on our peaceful sleep. The people who want to make an unpopular move, but fear the repercussions. The dreamers who long to do. I see you and feel you, because I am you.

In that lonely space, it can be easy to shut others out, immerse yourself in distractions, and practice avoidance of whatever the crux of the conflict may be.

My favorite musical is Jonathan Larson's *RENT*. I can recite every word and went through multiple copies of the double disc CD because I listened to it that much. I've seen the show on Broadway, on tour, and in local productions. I would give you a quantitative number, but to be honest, I lost count. In 2015, I choreographed a local production, so the depth of the text was fresh in my memory.

The narrator of the show, Mark, is a filmmaker. During a peak level of conflict in act two, Mark's friend and roommate, Roger, frustratingly calls out Mark's apathetic approach to life. Roger insinuates that Mark passively hides in his work, behind his camera, from fear of facing the world around him. In this show, Mark's world consists of a number of people suffering and dying from the AIDS epidemic. Mark jumps on the defensive, insisting that his apathy is a coping mechanism for survival.

The show covers a year's timeline from Christmas Eve to Christmas Eve, and the above moment happens around Halloween. During a fall day in 2016, I experienced this moment that happens during the song "Goodbye, Love" playing in my car. The reality of the lyrics hit me like two tons of bricks. I had listened to it hundreds of times previously, and it had never struck me this way. I had tears in my eyes and had to stop the car.

In that moment, I saw myself in Mark, numb and desensitized to the world around me. That wasn't who I wanted to be, but my fear of disrupting the status quo was keeping me in a place I didn't want to be. I had to find the courage to step out of the apathy. Changes had to be made.

I hope my story will serve as a road map for how life circumstances and scenarios can inspire you to not only survive but to push harder, motivate further, and advance your mission and impact as you grow in your personal power.

Because if there are three things I know, it is: (1) we cannot always control the horrible things that happen to us or around us; (2) we can make it through really tough times; and (3) the arts can inspire us to survive, thrive, and feel alive.

These are three affirmations I will forever believe. In my well-lived thirty-six years of life, I can take any scenario and assuredly feel these three things. And just like rehearsals for a show, if you regularly practice perspective, most events and circumstances can present education, growth, inspiration, or opportunity. For years, I've saved up quotes, mantras, and affirmations that inspire and motivate me as I move through moments. As I've dealt with one crazed situation after another, they've helped me maintain focus for my life.

The horrible parts of life will never disappear. Instead we have to learn to live with it, handle it, and allow it to lend itself to a greater cause and purpose for our personal fulfillment. With the right attitude, we can even be positive in spite of it.

And on the days when all else fails, pet your dog.

Because dogs make all moments better.

Chapter 1

DARK DAYS

IN THE THEATER, "dark days" are the days where shows don't happen. The theater is literally dark. Traditionally, a ghost light is left on the stage as the vibrant days of performance are interrupted with a calm, solemn pause.

Early in the pandemic, it felt like everything was having a "dark day." I was exceptionally stressed and feeling frenzied. My aunt texted, "Go hug Elvis."

Elvis is my Scottish Terrier, and John and I were creating Broadway-inspired vignettes that featured Elvis. We called those sessions "Elvis Hamilton Nightly!" and posted them to Instagram and TikTok.

One night, I suggested we recreate the scene from *The Phantom of the Opera* where the Phantom and Christine are moving through the canals towards the Phantom's lair. To set

the scene, we emptied Elvis's wicker toy basket and lit candles and placed them on our hardwood floors. We put Elvis in the basket, turned the music on in the background, and I crouched behind the basket, pushing him slowly while John filmed and handled cinematography.

It tickled us, but it tickled the world even more. That was our first taste of going viral. People loved the content, and it was our moment to artistically shine in an unconventional way. It was also our way to cope with the unknowns beyond our 984-square-foot condo, where we had been for days. Distractions were a welcome break.

It wasn't just us. Artists were creatively connecting in every way imaginable. Andrew Lloyd Webber was showing his varying works on YouTube for free on the weekends. Zoom concerts, show reunions, and Q and A's were happening left and right because everyone was home. A new *Ratatouille* musical developed over TikTok.

These moments helped alleviate the tragedy of what we were all suffering and experiencing, but it did not remove the gravity or uncertainty.

The last weekend of February 2020, a few dancers and I attended the University of North Carolina School of the Arts Festival of Dance in Winston-Salem, North Carolina. On our way, John was talking about coronavirus and watching the dots on the Johns Hopkins map pop up as cases appeared. He's a transparent worrier, so this didn't strike me as terribly unusual. I took it with a grain of salt.

Our best friends, Brad, Jaimie, and Will, live in New York City and attended that weekend with us. Upon their arrival,

John immediately pulled up the Johns Hopkins map on his phone. He showed it to them and asked if they'd heard anything about the coronavirus.

Brad and Jaimie are both medical professionals, and they hadn't. When Jaimie and I went to lunch, we even looked at each other and wondered, "How bad could this possibly be?"

We went about our business that weekend, riding in packed Ubers, hanging in hotel lobbies, playing sweat-inducing games of foosball, and sitting closely together indoors in restaurants. When we left Winston-Salem on Sunday, we didn't even say goodbye because John and I were flying to NYC on Wednesday. A goodbye wasn't needed when we'd be seeing each other so soon.

In the days in between Winston-Salem and NYC, I wanted to grab a few supplies for the studios to be extra prepared. I do not enjoy getting last minute supply requests, especially when I'm traveling. I decided to be proactive and headed to Target first thing on Monday morning. As I entered the store, it felt weird. Sections were ransacked. There were no Clorox wipes, Lysol, or hand sanitizer to be found. Purell was never considered a luxury, in-demand brand, so this felt very odd and slightly eerie.

When I got back to my car, I opened an email on my phone and saw a message from a client asking what type of heightened sanitation procedures we'd be taking in the studios to combat the new virus. What could this virus possibly have to do with our cleaning procedures? I couldn't wrap my head around what was happening, but I knew I needed to do what I had to in order to appease our clients. If cleaning was about to rev up,

more supplies would be necessary.

I moved on to a few more stores. It was the same scenario in every single one. There were no supplies.

With our trip quickly approaching, I was starting to feel a little on edge. I'm not one to cancel travel, but something felt really off in the world. Everyone was reassuring me that it would be okay, but words like quarantine and isolation were popping up left and right. After having the norovirus once on a cruise ship, I was not interested in being stuck, sick, or quarantined anywhere other than my home.

John felt like we'd be able to go. Because of his extreme caution towards, well, everything, this gave me comfort. I wanted to go because I'd been awarded a seat at the Tory Burch Embrace Ambition Summit. I had snazzy new business cards printed that featured my new website and personal branding. As excited as I was to launch some next-level career moves, I couldn't shake the feeling that something really unnerving was about to happen. One morning as I was rushing out the door, I ran back inside to shove my laundry from the washer to the dryer. As I frantically completed the chore and gathered my belongings, I felt a tightness in my throat and thought to myself, "The world cannot continue moving this fast."

Still, I packed my suitcase and we went through all of the routine motions of going on a trip.

As we prepared to head to the airport, we got the text notification everyone dreads:

Flight Canceled.

We waited around through four more cancellations before we finally pulled the plug and stayed home. It would be a prelude

to the days, months, and, to some degree, years to come.

The following days, I tried to figure out what was happening so I could get a plan in place. How do you plan for something that has never happened in your lifetime? I closed the lobbies of the dance studios. I started recording very imperfect videos to share with students. I snagged a Zoom account when Zoom still provided individualized customer service. At one point, one of our long-term instructors half-jokingly looked at me in my office and said, "This is too negative and stressful. I've got to get out of here."

The tension continued to escalate. Panic started to set in.

I remember walking the aisles at our local grocery store, Harris Teeter, buying ridiculous foods like Bagel Bites, Little Debbie Raisin Creme Pies, S'mores Pop-Tarts, and Cape Cod Potato Chips. The pantry looked like we had just moved into our college dorm.

While at the grocery store, Jaimie, the friend I should have been having dinner with in NYC, called and said, "Rumor has it they're shutting down Broadway."

Wait. What?

Broadway? Shutting down?

No.

My mind couldn't even begin to process it.

I raced home and noticed even more dots popping up on the Johns Hopkins map, which was now being featured regularly on every news outlet.

The first case of COVID-19 had recently been identified in Raleigh at a restaurant named Soca. While they gracefully handled what felt like a publicity nightmare, the shock, fear,

and divisiveness of the virus rippled through our community. As a business, I couldn't help but wonder what would happen if that happened to our studios. Would we be next?

A closure was looming. I felt anxious, stressed, terrified, frustrated, angry, and fearful. It didn't seem possible that we were this unprepared for a virus. Selfishly, it didn't seem fair that it was about to wreak complete and utter havoc on my world.

On March 14, 2020, I emailed my staff that I was closing the studio the week of March 16, and we'd be moving to a digital format that we were in the process of figuring out. At the time, I confidently declared, "Maybe this will be the beginning of the SDD Global Division!"

Forty-eight hours later, on March 16, I was flying high from way too much coffee and adrenaline. We had a fully digital platform ready to roll based on a teleconferencing platform I discovered while chairing the Park Scholarship Symposium at North Carolina State. Mind you, I'm not a technology person. I stayed up late and read, watched video tutorials, and thought about how I could make this work. A duplication of the dance studio would never work in the virtual learning realm. We needed to take what we typically do and expand upon it to enrich the client experience.

As I restlessly laid awake at night, my thoughts kept going to quarantine and cruise ships. From the few cruises I've been on, I love the organized schedules each day that allow cruisers to pick and choose their entertainment. At night, they slip the schedule under your door or place it on your bed with a fancy towel sculpture. As a Type A planner, perusing these schedules

and planning the next day were one of my favorite activities.

I reflected on that experience and thought, "What if we could create something inspired by that model that would operate throughout each day?" The consistent presence would help our hundreds of dancers maintain connection and a sense of normalcy during a time of chaos.

The schools were closed and were not moving quickly into their alternative model. I sort of understood the bureaucratic component, but I will also never understand their lack of urgency. From the difficulties and hardships I had experienced, I knew our students needed some sort of routine. We could provide that by making their passion and artistic outlet readily accessible throughout the day to boost focus, engagement, and general well-being.

If this virus was going to be as extreme as they predicted, we needed dance and we needed each other. As a child, I experienced trauma and the arts were my go-to. I knew many of these children and teens were about to experience some sort of trauma and loss, and we needed to do our part to be there for them.

We set up our program with two major components:

1. **REHEARSAL AND CHOREOGRAPHY WINDOWS:**
 Shortened class times where students would work in their traditional classes with their instructors to learn and set their choreography for the spring recital. We always start our recital choreography in March, so this meant our students would learn their entire routines through a format we'd never used.

2. **CRUISE SHIP CLASSES:** These classes were offered

throughout the day, every day, Monday through Friday to entertain our dancers. They ranged from technique to themed events to trivia sessions to history and theory. Nothing was off-limits. We danced with our dogs, family members, and had more themed events than I'd previously thought was possible. The Digital Easter Egg Hunt was one of my favorites.

Once we activated our new platform, SDD Digital!, we never stopped. We didn't even take a spring break. I couldn't stop. One night, John looked at me and said, "You cannot work like this for so many hours every single day." But I didn't know what else to do. Everything I'd ever known and everything I'd created was on the line. We had to be resilient as we went head-to-head with an even more resilient enemy: the pandemic.

As our team pulled together in an innovative way, I started tracking the economic loss. I was curious how it might impact our ability to sustainably make it to the other side.

Instantly, we lost all external programs, including satellite programs at country clubs and preschools, contracted theater opportunities for choreographing musicals, and regular rentals for our studio facilities. This equaled tens of thousands of dollars in revenue each month, and it was gone in a blink.

Then we started tracking our internal drops. This part was not only economically painful, it was emotionally devastating. Every drop and farewell felt personal, even though, for the most part, it had nothing to do with us. We had parents experience uncertainty from the hotel and events industry. Jobs were being lost or furloughed, and nobody really knew who would make it or who wouldn't.

Other families were understandably stressed. Our customer

service phone lines and email stayed open, so we listened to a lot of concerns. We knew that parents were fearful of the virus and its transmission and wanted to protect their children. We knew that parents were nervous about juggling working from home, schooling, online extracurriculars, and life without their typical support infrastructures. We knew there were students who would not thrive on the digital platform.

All of the concerns made sense.

It didn't alleviate the horrible feeling when our dropped student metrics went from the single digits to the double digits to the triple digits during the months of April and May 2020.

Enrollment and revenue took a nosedive in a way I never anticipated.

We kept hearing that financial "help was on the way" for small businesses, but it wasn't coming fast enough. Dance studio owners were depleting their savings and taking second mortgages out on their houses to survive.

During this time, I crunched numbers more often than I should have, and the outlook was grim. When the first major relief program, the Payroll Protection Program, rolled out, small businesses clamored in a way that mirrored people seeking lifeboats on the sinking Titanic. It was stressful because this funding was a necessity that had to happen for us to survive.

In the first round of Payroll Protection Program funding, we were denied. The red tape required for receiving this funding was unreal. We'd been diligent and detailed in our application process, so when I received this notification, I was devastated. After the bank told me I needed to spend my time lobbying legislators, I felt enraged.

I was being asked to run an entire business in an alternative format due to the government mandated shutdown, pay our commercial rents at the full price, keep our community intact, motivate our staff, find alternative funding, practice public health policy, and facilitate frustrations day in and day out. On top of that, they expected me to find time to lobby our legislators? Unreal.

On April 16, 2020, in a humbling, rare public plea, I took to my small Instagram following to share the frustrations of being overlooked as a small business owner. This is a very atypical move for my private personality, but I felt like it had to be done.

Within hours, I had a call from the dad of one of my former employees. His role was market executive at a commercial bank, and, being a smaller, more local institution, he felt like he could help us navigate this overly complex funding process. When I answered the phone, he immediately said, "My daughter speaks so highly of you and feels that if anyone in this world deserves this funding, it is you. She saw your video, and I'm calling to tell you we are going to make this happen."

And in that moment, a wave of emotion flooded over me as an unexpected guardian angel popped up in the seemingly most abysmal of times. Sometimes, we have to look really hard or do things we wouldn't normally do to find the good doers. That small but mighty video created quite the ripple. In speaking up, I showed up for myself and for others.

I talked to other small business owners and inspired them to keep going and continue fighting for their livelihoods and passions. I was connecting with current and former clients as we shared our successes and struggles.

In retrospect, I think people appreciated the transparent

truth about our position. We'd never been in this place before. I knew what worked one day may not work the next; still, we had to keep going. We were all handling the horrible together, and in recognizing and uplifting others, we were easing the burden.

Amidst figuring out how to financially sustain, we had a lot of other complications to navigate.

REOPENING

In the state of North Carolina, dance studios were lumped in with gyms in the brazen categorization of businesses that were mandated to close. Our governor would have weekly press conferences where he'd update the state of affairs and announce what could and couldn't be open and at what capacity.

While I can appreciate safety and caution, I became skeptical about the decisions being rooted in science and data. "Dancing" was being treated the way it is in the movie *Footloose*, and this response was undoubtedly making people unnecessarily fearful of what we offered.

As other businesses started reopening around us, we were told time and time again that we'd have to remain closed. I started having very visceral, anxious responses to the announcement of a press conference. In response to the press conferences, I'd ugly cry, lose sleep, and panic.

Staff members started volunteering to sit with me through the press conferences, and I appreciated the company. After one particular event, I was in such a brain fog that I decided to lean into an old comfort, shopping at HomeGoods. As I walked the aisles of HomeGoods, I felt defeated and questioned how shopping for

home decor was deemed safer and more essential than dancing. I barely remember the actual trip, but I remember how disconnected I felt from the world because I couldn't believe this external experience was impacting everything I had worked to create.

I was working like it was year one of the business. I tried every trick in the book and nothing seemed to be enough to pull us out of the nosedive. It felt like one beatdown after the other. One night, I was sitting in my office, and the last staff member to leave was packing up for the day. A text notification went off on my phone. I looked down and it read, "I'm sitting in the parking lot until you leave. It's time to go home. You've done what you can today."

There were many days where the work I did didn't feel like enough. "Rise Up" seemed to play in the background of everything. I was sick of the gloom and doom because I was broken down and tired, and there didn't seem to be an end in sight. After one particularly devastating press conference in May 2020, I cranked Lady Gaga and Ariana Grande's "Rain On Me."

Through the bump of the beat, my former fixation on frustration shifted into another level of innovation. I raced to pull the details of the latest Executive Order. After painstakingly reading every detail, I realized we could reopen…as a summer camp facility. And, that's when Camp SDD was born. After Camp SDD, we opened The Academy and Perform Learn Play Programs. These programs collectively pivoted us into recovery mode.

Mind you, I typically run dance studios.

Now, I was running a day camp facility, a remote learning

program, and a pre-K experience while boosting morale with drive-through parades, curbside costume pickup, and a million other things I never envisioned being a part of my professional path. On top of that, there was public health mitigation, general anxiety, demanding questions from the public, and grant writing that was required to be financially solvent.

Most days it felt like the house of cards could fall at any given moment.

PERFORMING

During the pandemic, live performances were the first to disappear and the last to return. This destroyed me because performance offers so much opportunity for catharsis, community, and healing. Without warning, they were all gone.

For the dance studios, our performance pieces are simulators for our students. By practicing performance, they improve their craft, confidence, and personal selves. It is a paramount piece of our experience, and it is something I anticipate like others anticipate Christmas. In my entire life, I had never missed a recital, and I wasn't about to let 2020 be the first.

By late April of 2020, we knew there was no way we'd be able to have our traditional recital, so we started brainstorming alternative options. On one staff call, I remember mentioning the idea of an immersive experience. Our theme was "Lessons from Oz," and I imagined each room of the studio being transformed into something special: Kansas, Oz, the Emerald City, and so on. Lofty, I know, but I was going for it. We were going to make this happen, even if it couldn't be in a theater.

As the weeks continued to pass, we went through performance scenarios A, B, C, and likely all the way down to Z, as we figured out what we could possibly do to perform. We eventually realized that anything indoors seemed unlikely as we were still under a shutdown order. We had to determine the logistics of an entirely new experience on a very tight timeline with a virtually nonexistent budget.

We landed on turning our annual recital into a "movie shoot" in our parking lot.

We filmed 142 routines over a three-day period at the end of June in the sweltering North Carolina heat and humidity. Each morning, we'd refresh the chalk outline of our "stage drawing" that also served as six-foot boxes to meet social distancing guidelines. We asked dancers to change in their cars. There was no audience except for a few staff members who would whoop, holler, and cheer louder than we ever have before. It was wild, but it was freeing and fun because we were able to see each other and share in this joyful moment that we had missed more than we even knew.

Our videography crew were rockstars, and I will be loyal to them forever because of the way they treated us. At the end of the weekend, rain started to fall. I looked at the company owner, Curtis, and I nervously asked, "Do we have to stop?" Without hesitation, he said, "I will stand out here in the rain until every child is filmed." And, in solidarity, I stood out there with him.

Cling tight to the people who see you, show up, and stand with you, unwavering, in your belief. The people who will fight with you, for your cause, are true treasures that should not be taken for granted. They're the angels who guide us through

the grim and provide inspiration as we push to the other side.

EXTENDED INSTABILITY

I wish I could say that COVID was this weird, short chapter that we lived, survived, and addressed. At some point, we will be able to say that. But that time isn't now, and we continue to live "in the dark" that took over in March 2020.

Sure, we know more. Thankfully, the doors to the businesses are open. Still, there's this looming sense of uncertainty and unrest.

It's weird to have your business valued on something so far beyond what you actually do.

Clients quit dance class because of our city's required mask mandate.

Clients chose not to return because of the inexistence for a vaccine for our youngest dancers.

Variants created rippled waves of panic.

Anxiety and mental health have impacted extracurricular success in a variety of ways.

The school systems and their varying levels of instability have created a challenging environment for after-school success.

People are tired, exhausted, and doing their best to juggle it all. But in some cases, the one thing that has to go is dance class.

When your business model is based on expansive commercial square footage and quantity of heads in the classroom, that's tough.

We have no crystal ball. We don't know when we will return to a fully normalized operation.

As a Type A planner, that's been an impossible feeling to wrestle, but I maintain my optimism that it will be soon.

There's a book I love that I'll speak more about later, but its author, Steve Leder, is a rabbi in Los Angeles. The man knows loss. This quote really stood out to me: "Catastrophizing is a terrible waste of physical, psychic, and spiritual strength when we need it the most, and believe me, one way or another, whatever outcome you are imagining will be wrong in any case."

I cling to the notion that this prolonged period of instability will give way to a tremendous celebration in the future. I've embraced the creativity and innovation this time has required and recognized how it will continue to help us grow as we evolve. Leaning into this positive outlook has required intentional work.

Early in the pandemic, a friend I admire received her executive leadership coaching certification. She reached out to me, in case I needed some support navigating the myriad of challenges. I wasn't in a position to say no, so I cautiously jumped in.

As soon as we started our sessions, I realized the toll the day-to-day survival of the pandemic was having on my ability to strategize my vision for the future. I needed to think past the present moment, and I was having trouble doing it on my own. In our first few sessions, I was even having trouble doing it with her.

As we progressed, I wanted COVID to become a non-predominant topic. It was there, but I needed to stop it from being all-consuming.

To do this, I would create meeting agendas that centered around exploring hypothetical "what ifs":

- What if we scaled?

- What if I launched a speaking career?

- What if I started coaching and helping others?

I didn't know which, if any, of these would come to fruition, but I was putting in the work to maintain a growth-oriented mindset. When things aren't going our way or feel out of our control, it is easy to push our forward-moving visions to the back burner while staying stuck in the complacency of the frustrations of each day. It's a trap, and we must be diligent to not allow it to drain our passion and enthusiasm.

When you feel your heart, your soul, your voice getting lost or paralyzed, do everything in your power to find it, feed it, and protect it. Because that's your power, and the world deserves to know you.

Let your fears make you fierce.

The dark days provided a prolonged look at leadership, adaptability, resilience, and self-care. As we creatively navigated the unknown, we found ways to keep it all going.

Time and time again, we would:

1. **ASSESS**

2. **RESPOND**

3. **MAKE A MOVE**

This condensed, three-step protocol kept us focused and in the game. It was simultaneously taxing and rewarding as we experienced the worst of the world combined with the best.

One day, I was caught off guard when I received these kind words in an email:

First off, amazing job. Really. I told my husband that if you were in charge of this whole pandemic, we wouldn't

be in this position right now. I think my quote was "Chasta Hamilton and Glennon Doyle could handle this entire thing, in a reasonable amount of time. We should put them in charge."

I responded:

Thank you. This has been crazy, but I'm a buckle down, let's make it happen, despite the circumstances, kind of girl.

In that one-sentence response, I provided a snapshot of who I am.

Through the longest, darkest, most uncertain period of time, I affirmed the strength in my voice, leadership, and direction. It had been years in the making. When you're asked to do really hard things, your inner truth has the opportunity to shine. What gives your inner truth the power it deserves?

Chapter 2

A PLACE TO FIT IN AND STAND OUT

THE ARTS ALLOW you the opportunity to simultaneously lose and find yourself. You can discover glimpses of who you are and who you want to be. You can feel a range of emotions: from the shock of the horrors of the world to the warmth of the possibility of humanity.

We can laugh, cry, and feel together, and afterward, we walk out ready to make the world better because of the short time we spent listening, hearing, feeling, and understanding someone else's journey.

If we simulate this process of performance as an observer of our own lives, we create a deeper awareness of our place within this world.

Everyone loves a good origin story.

What shaped you into who you are today?

For me, it all began with my parents, Russell, a basketball star, and Karen, a cheerleader, who were adorable high school sweethearts. They were two people who loved their life, their families, their passions, and me.

We lived on 12.5 acres of countryside land in Mohawk, Tennessee with a winding gravel driveway that led up to the mid-century, modern architecture house my mom designed. It was out of place and ahead of its time, but it was perfect for us.

Learning to ride a bicycle was impossible because rocks would shred your knee upon each fall. Trick or treating didn't happen in the traditional sense because nobody lived close enough to walk from house to house. The eerie quiet of the pitch-black night was juxtaposed with the effervescent stars, little diamonds in the sky.

Our existence as a nuclear family was short-lived as both my mother and my father would be prematurely taken away from this earth. My father is primarily a figment of my imagination, as he passed away prior to my second birthday. For the nine years and six days I knew my mother, I was moved by her ethereal presence.

In my mother's short time here, she gave me the greatest gift possible: the gift of dance class. From the age of two, I became enchanted with the process of training, performing, and producing shows in actuality and through my imaginary play. From an early age, I was able to embrace the fact that there is always magic, and it can be found even in the midst of tragedy.

Towards the end of her terminal illness, I remember her

walking into our living room. I was playing "performance" with a Crayola sixty-four-count box of crayons. She sat down next to me, realizing that I had creatively converted each crayon into a role in my imaginary production. The crayons were "performing" on the "stage" that was the stone hearth of our fireplace.

Quietly, she said, "Even if we had nothing, I know you'd find a way to play."

And play I did.

Growing up, the magic, for me, was in the distraction-free opportunity to discover my passion. With no internet or cable television for the majority of my upbringing, I had plenty of time to dream, create, and play. These are three things I attempt to do every day, to this date.

While most tragic tales have fairy godmothers, I had an entire community. This community raised me, cared for me, and never once allowed me to question my value or my worth. After my mother's death, my mom's sister, my Aunt Cheryl, paused her life, retired early from the Air Force, and moved back to Tennessee to raise me in the mid-century modern home. As a nine-year-old, you don't necessarily realize the significance of that sacrifice, but as an adult, I feel extreme gratitude each night as I fall asleep and each morning when I wake up.

The people who surrounded me told me I would go far in life, and I took the opportunity to pursue and achieve that very seriously, in spite of any and all circumstances. When I graduated high school, one of my childhood best friends, Elizabeth, gave me a custom-made ballerina Build-A-Bear. The bear is snow white and wears the most perfect, cotton candy pink tutu. It came with a note that said "If anyone can run a dance studio,

you can. Go for your dreams." That bear has sat on every shelf of every place I've lived since 2003. And Elizabeth now lives in my childhood home, a truly beautiful, full-circle moment.

When I wasn't dreaming of how far I'd go, I used education as a way for me to escape. So whether it was a fascinating topic in school, a new perspective from a friend, a thought-provoking movie, travel opportunity, book, or my extreme passion for my extracurricular activities in dance and theater, I went all in. I even graduated high school early and spent part of my senior year on a college campus with another one of my childhood best friends, Stephanie. That semester was a controlled taste of independence, and the memories of sleepovers, dinners out, and *My Best Friend's Wedding* on repeat will always be some of my most treasured times.

As I was attempting to figure out this game of life, I never had a sense of success looking a certain way. My vision wasn't attached to a salary, job title, or other flashy things. I simply wanted to find something I love, and by doing it, I wanted to make an impact on the world. There's no doubt this stemmed from my awareness that the trajectory of my life could have looked much different. As an adult, the reality of how people pulled together to care for me is an example of one of the greatest acts of humanity.

Because of my unconventional childhood, I embraced a life that veered away from many of the expectations of societal construct. How do you live a "normal" life when the most "normal" act of all, being raised by parents, is taken from you? In my adult life, many people have paralleled my parentless upbringing to living a "Disney princess life." Eh, not quite.

But at least we aren't still living In the old-school Disney days, where that might mean I was waiting in a tower for a guy to show up and kiss me.

Instead, atypical female heroines are being represented in the media, and it is exciting. Belle of *Beauty and the Beast* unapologetically loves her books and her quest for intellect. Tiana of *The Princess and the Frog* craves entrepreneurial success, including the hard work required to get there. These two undoubtedly paved the way for the meta success of *Frozen*. Elsa is an independent, conflicted leader who wrestles with her power, literally and figuratively. For years, I've watched children love, celebrate, dress up, and sing "Let It Go."

When children sing this song, I wonder if they realize the gravity of the hard, challenging, misunderstood life of Elsa. Most likely not. Instead, her perseverance, resilience, and love for her sister inspires and influences them, which is also great. While parents flock to this character in the form of mass media and consumerism (yes, in 2014, every child in a class of eighteen four- to five-year-old dancers wore an Elsa dress to class), many resist it in the form of execution.

Can you blame them?

Who wants to bestow a hard and difficult adult life upon their child? No one, myself included. There's power in recognizing that even if we don't want to emulate these stories, there are lessons to learn and apply that will empower our place in society.

My childhood was disrupted from the norm, and yet, through perseverance, I gained a greater strength to my story and myself. It was only recently that I started recognizing the

power of my path. If you are facing challenges or feeling slightly astray from the mainstream, leverage those feelings and allow yourself to elevate.

In 2019, I did a one-on-one leadership coaching session with a successful, fellow female business owner. I had focus, and I had vision. In fact, I had so much vision I wasn't sure how to prioritize which way to go next. I needed an outsider's perspective. In our chat, we focused on strategizing goal achievement. In the conversation, she said, "You're a disruptor; focus on the ways you are changing the pace of the world around you."

That was a meaningful moment.

How often do we need validation to affirm our inner calling? It's almost as if someone else is using their voice to speak our truth, making us more powerful. That was the first time an outsider had labeled my version of going against the grain as admirable, and it felt good. In owning the idea of setting a new pace, I felt empowered. I'd been quietly doing my thing for so long and was excited to be more vocal and committed to my positioning.

I've always wanted to be an influencer of change, but have failed time and time again to actually make it happen within other organizations or venues where there was deep-seated ritual and routine.

When I auditioned for the dance company at North Carolina State, I didn't make it.

When I interviewed for my first two dance teaching positions, I didn't get them.

When Stage Door Dance opened, I wanted to be accepted as a credible institution in the dance education industry. I knew

we could do this through Dance Masters of America (DMA). I grew up dancing in the organization, and I loved the organizational focus and the community it fostered. I was naturally excited to become a member and share my love of DMA with my newest love, the studio. When I joined, parts of the operation seemed stagnant and lacked efficiency. I was excited to jump in and help so that more young studio owners could share this experience that meant so much to me.

Nervous about how to approach it, I reached out to someone I admire within the organization who is a force of change in the dance education industry. I was young, and I'm not even sure I expected a response. The answer? Run for office. Kindly use your voice.

Over the coming years, I served in my chapter and national leadership. I made some of the best friends and mentors imaginable. The organization attracts some truly exceptional people. At times, I felt frustrated because I didn't feel like I was making progress or enacting change. I kept seeking higher positions of leadership. In the election cycles, I lost a number of times, including two disappointing rounds where it was made clear that the status quo would prevail.

In the moment, those two losses felt disappointing. In retrospect, that was my ego speaking. The blow of a no can be so hard to take in the moment. After many letdowns and detours, I can confidently say that most rejections offer a segue to something greater. In this case, I realized I was better off being a member in the organization and using my leadership in areas where I could readily activate change.

You and your ideas have power. There's an art in finding the

perfect place to land. When something says no, that's usually a directive that somewhere, in another way, you'll be able to say, "Let's go." And when you do, it will lead to something much better than you initially imagined. Everything we experience paves the path for our self-development.

FLYING SOLO

When you are eager and ready to go all in on a project, it can be frustrating and hurtful when your ideas are rejected or met with resistance. Early in my professional career, I learned this the hard way with my first career step containing artistic direction. I was young and in college, but that didn't stop me from being fully committed to excellence.

I was hired to teach tap at a dance studio, but my responsibilities quickly grew. The same thing happened when I worked retail at The Limited. I was a reliable employee and wanted to serve the best interest of each organization.

At the dance studio, I was beyond excited when I was entrusted with developing the contemporary divisions of the school. This is what I had dreamed of doing, and I wanted to do it well. I loved the environment, my colleagues, and the dancers. I learned so much from the owner of the school, and I wanted my product and leadership to make her proud.

As I continued to prove myself, I was rewarded with more opportunities, including the opportunity to lead a dance team at a private school, as well as the freedom to create and cultivate a contemporary style performance group.

As my work gained popularity within the program, I could

feel the tension growing with my colleagues, especially those who were close in age. I was young, intimidated, and didn't really know how to handle the conflict. To me, success for one is a success for all, and I didn't understand the issue. I wanted to defend excellence in my work while also keeping the peace. When the conflict reached a tipping point, I tried being honest and transparent.

The issues began when it was announced at an October staff meeting that all my previously scheduled company rehearsals would be canceled in November and December to focus on Nutcracker rehearsals. This concerned me because it: (a) was contrary to what parents had been told; (b) did not justify their monthly payment for the program; and (c) compromised my integrity as a leader of a subsidiary organization of the company.

After the meeting, a staff member approached me and commented that she "hoped the leadership team wasn't too hard on me" regarding the shift and adjustments within the performance company. In response to my surprised reaction, she further explained that she had reported the performance company students were "losing technique," an out of place and unfair judgment that was a direct attack on my leadership. To this day, I have no idea what motivated this staff member to throw me under the bus without including me in the initial commentary. I can still feel the discomfort of standing in the hallway, looking this person in the eye, as she unapologetically owned her success in knocking me down.

Hurt and angry, I initially approached the leadership team in hopes that we could reach a mutually agreed upon resolution. After some back-and-forth dialogue, it seemed that it might

not be possible; and for the first time in my career, I knew it was time to move on. I was gutted because everything I had worked to achieve was about to be gone. Writing my resignation letter for this position was my first, true professional heartbreak.

In the letter, I detailed the difficulty I had in making this decision. I reiterated it was professional and not personal, and I expressed my gratitude for what this program had given me. I also reiterated why I was making this choice: (a) the controversy surrounding the company that seemingly would never reach its fullest potential; (b) the overall vision of the program and how it contradicted my goals and vision; and (c) the growth potential available for my needs as an arts entrepreneur.

It was a respectful letter. If there's one thing I've learned along the way, it is to stand up for your brand and what you represent, even when it feels horrible. Self-advocacy is self-care. How often do we avoid being honest because we are so fearful of how our truth might make others feel? Our voices should not be silenced because of the potential discomfort.

This entire process left me unsettled, but it was the right choice. At the time, I didn't even know what might come next. After I sent the letter, we had an in-person meeting at a Bear Rock Cafe. I had eaten so many Hoot Owl Sandwiches with huge chocolate chip cookies prior to many wonderful dance classes. This time, that anticipatory joy didn't exist. I was so nervous I was physically shaking.

I understood the anger and disappointment of the organization; they wanted me to reconsider staying in the position. I didn't see how that was possible. They asked if my departure was financially motivated. That question shocked me, because it

wasn't financially motivated at all. That's the moment I realized that a career built solely on a set salary didn't motivate me. I wanted to create something unique and special.

After the conversation, I left Bear Rock Cafe as well as my position and did not serve out my fifty days' transitional notice. There was a bridal shower for my first marriage scheduled for five days after this meeting. The organization was hosting it, and after the meeting, we mutually agreed to cancel it. I was slightly mortified as I notified all the guests and sat in the quiet, wondering if what I had done was right or wrong.

Ultimately, I stood up for something I believed in. That is hard to do and a tough lesson to learn. As you practice the art of aligning with what you will and will not tolerate, you gain confidence in your standards as well as practice in managing the disappointment, anger, frustration, and reactions of others. I wasn't good at it then, but as with any skill, if you practice enough, you will improve.

During this period of time, I realized I related in many ways to the character Elphaba in *Wicked*. When the musical opened in 2003, I was desperate to see it. I wouldn't have a chance until 2006 when the tour was making its way to Atlanta, Georgia. I offered to buy my aunt and me tickets if she purchased the hotel room and drove us. She agreed. I was a college student at the time, so I tutored Ancient History for sixteen hours on one Sunday in the library to purchase last-row seats off of eBay in the Fabulous Fox Theater.

I remember feeling so inspired at the end of the act one tour de force, "Defying Gravity." Elphaba finds her freedom and confidence. If you haven't seen it, pull up the Tony Awards'

performance video on YouTube. It's worth the watch, and it's inspiring to see this character following her gut even though it is contrary to the expectations of everyone around her.

As I entered this new era, I did some soul searching and made the decision to open my own dance studio. I had dreamed of doing this since I was a child, and this was the sign that it was time to pursue it. Venturing out on my own was a risk that meant quitting all my freelance teaching and choreography work. I had to deal with a lot of reactions, which ranged from ghosting to lecturing to being passively supportive. It was scary, but it was scarier to consider the prospect of never attempting to live out my dream.

People have a hard time figuring out those who are confident in their ability to express their wants and needs and are often intimidated when people go for it. They become even more intimidated when there's hustle and heart behind the move. Making it happen is powerful.

And while wants and needs may not always work out the way we envision, the ability to express them is essential in reaching our fullest potential. Dreams develop in their own time as a by-product of our thoughts and experiences. We should never sacrifice our calling for convenience. A circle cannot fit into a square, and the longer you try to do it, the longer everyone involved will suffer.

THE CALLING CARD

There's this misconception that the self-employed get to do anything they want, whenever they want. That's kind of true

because you have the ability to set your own schedule, but it is also very false. A crisis can happen during holidays or something may go awry when you're traveling. When you work for yourself (and you do it well), you hustle harder than you ever imagined possible. You're never "off," per se, because you shouldn't have the expectation that anyone will care about your business as much as you.

You celebrate wins, but you internalize failures. When revenue is up, you get paid. When revenue is down, you don't. Dealing with dissatisfaction can feel like a personal attack. As my father-in-law says, "Owning a small business is like waking up and drinking out of a fire hydrant every single day."

If you know, you know.

Social events become networking opportunities. Travel becomes an inspiration board for business operations. The wheels are always turning because you continually strive to improve.

Once I left my freelance jobs, I was hungry for anything and everything that could make my business concept the best institution and organization I could possibly create. This meant going beyond the walls of our building to bring back knowledge and innovative ideas, not only from the dance education industry but from every industry.

Fragrance at the Renaissance Hotels? Let's get it at the studios.

Client onboarding and offboarding on Disney cruise ships? Let's emulate it at recitals.

The joyful staff at Sherwin-Williams? Let's energize our team to make that kind of initial impression.

It's a continual cycle of learning. If you become stuck in what you do and what you know, you'll undoubtedly limit your growth potential and opportunity. Stagnation and complacency kill businesses. Just ask Blockbuster.

My small-town origin paved the way to big city dreams. I was committed to doing everything in my power to cultivate the best of both worlds. If I could merge the hospitality of my hometown with city sophistication and efficiency, we could offer something unique and exciting in our market.

I never presumed it would be an easy process. I did my due diligence and knew what to expect. Part of this realistic approach is credited to an early interview session with SCORE, a business mentor organization. A panel of retired executives questioned my business plan prior to activation to see if it was practical or sustainable. The interview was intense and thought-provoking. When I left, I felt simultaneously defeated and energized. And then I was offered a SCORE mentor who still advises me to this day.

In one of our early sessions, he offered the following advice: "Do not forget: you are now a business person first and an artist second."

As an artist, that was a tough but necessary pill to swallow. For those of us working in the creative space, how often do we become so tied to the process of the art (and maybe even our ego) that we lose sight of the focus of greater good?

From day one, I've tried to keep my focus on the collective, macro picture. When I make decisions, I don't do it solely in self-interest; I do it for the progress and vision of our brand and the elevation of our industry. Sometimes it may mean

sacrificing the song or choreography I initially envisioned. I may have to delegate something I really enjoy doing. It may mean reconceptualizing a performance or revisiting a curriculum.

How many times have you heard that business and art don't go together? I believe they can. And when they do, it can be a synergistic success on all accounts.

CONNECTION BUILDING

Once you know what you want to do, you've got to do it. This means getting out there, talking to people, and representing your brand or cause. Your voice is only as loud as you allow it to be.

In the early days, there was nothing we didn't do to say, "Here we are!" I would spend weekends taping business cards to mailbox posts and praying the people in the houses wouldn't come running out, yelling at us in rage. When one of the *Twilight* movies premiered, we took hot pink fliers and placed them on every vehicle at the midnight showing. It rained that night, and the next day, a person was very upset about the hot pink stains the flier had left on their white truck. I invited them over to the studio and paid for their car to be washed. All of the pink streaks came off.

I quickly learned the importance of talking to people, hearing their concerns, and accepting them for who they are and where they are at in their journey. I did this through joining service organizations, visiting moms' groups, participating in leadership programs, keeping up with my educational institutions, connecting with peers who inspire me, and building relationships with local and national arts organizations and stakeholders. If

this sounds exhausting, it is, but I'm proud of my circle and know I have an iron-clad Rolodex to reference at any time.

Networking is an uneasy necessity. There are times when I enjoy it, but in all honesty, I often dread the anticipation of it. For me, the feeling is similar to wearing tights in ballet class. You know it has to happen, but you don't look forward to it. Then, once it happens, it's not as bad as you imagined.

Networking has led to so many positive connections, relationships, and growth. To help manage the dread, I've developed my own rituals to hype myself up.

They include:

- creating a pre-event playlist
- setting interaction goals
- giving myself an exit strategy

Some days, I'm not into it. I once attempted to attend a Chamber of Commerce luncheon. It was during a very wild week in my life, and I really just wanted a roast beef sandwich from Arby's. I walked in, saw they were serving cheesecake for dessert (my least favorite), and turned around and walked right back to my car. I didn't beat myself up for this failed mission. It happens. Shake it off and give it a better go the next time around.

With connection and opportunity building, some days will be fruitful and some will be famine. Roll with it, and with enough perseverance, there will be rewards to reap.

Case in point: Michael, a New York City networking guru, introduced me to my inspiration buddy, Mike, a firecracker of a personality.

When I first met Mike in 2010, he was producing for a power-playing dance competition (the irony, I know). I was eager to judge on a circuit like his because they pulled in some incredibly talented studios. I had a feeling I'd meet some great people while keeping a pulse on the ins and outs of this particular side of the dance industry. I wanted to be a part of it.

Excited for the opportunity, I was taken aback when Mike blatantly told me, without hesitation, that he didn't feel as though I had enough experience to judge for a circuit at the caliber of his company. I knew this was false, so I advocated for myself, went through the interview process, nailed it, and was out on tour with them a few months later.

Our friendship grew, as did our hopes and dreams for the future. Over the years, we have had so many fiery conversations surrounding dance competitions, leadership, and vision. From karaoke rooms in Koreatown to Cookout drive-throughs in North Carolina, we've been a part of each other's journey from the figuring-it-out phase to the getting-it-kind-of-right phase.

To this day, he helps me see situations and scenarios from a fresh perspective. One summer, there was a prestigious, arts-oriented C-suite position posted as available. I considered applying for it. I love my current position, but it's healthy to stay prepared. It keeps you fresh and focused.

I texted him about my consideration, and he responded:

> *You are quite the ambitious unicorn! And you are worthy,*
> *deserving, and have earned the right to a role like that.*
> *You are a leader…so…I ask this question of you…If you*
> *were to take the same forty to sixty hours and do your*
> *own leadership in your own vision, where would your*

impact be greater…There or on your own project? If it
is there, you are heading in the right direction.

With one thoughtful text message, I was reminded that my leadership is best served when it is directed towards my vision.

You won't find a friend like that in every networking room or occasion. But that kind of connection is out there. You just have to be bold and brave enough to find it. Like a spotlight, these types of friends help us find our focus and guide the way.

Our connections are reminders of what we've built. When our nets are cast far and wide, we become beacons of our mission. When we find treasured connections, they're in place to remind us that sometimes the best place to be is where we already are.

TAKE ME HOME

I can still do the dance break of "76 Trombones" from my high school's production of *The Music Man*. I was just a dancer in the ensemble, but there's something about the lights and warmth of being on stage that has always felt familiar, like home. Similarly to the dance break, I vividly remember heading to Applebee's after rehearsals and shows to hang out and laugh over mozzarella sticks and potato skins. The process and the camaraderie are both incredibly powerful.

Endings of any kind are bittersweet, and I feel that's especially true in performance. As we reached the end of our senior year in our dance company, our dance instructor, Kristy Pratt, gently reminded us that this wasn't a time to be sad. Instead, she encouraged us to focus on the amazing experiences we shared in being part of this group for a short period of time.

Life would continue to bless us as we moved on to different casts, companies, and stages. All would play an important part in our lives.

Her words stuck with me, as did her untraditional fashion sense of Ugg boots, short skirts, and fingerless gloves. Kristy was a jazz dance queen who loved La Bouche and Marc Anthony on repeat. While she never hesitated to push us to our fullest potential, she loved her dancers and cared about our journey.

When I began dancing with her in high school, my technique was not where it needed to be. I wanted to improve, so I took private lessons and worked daily to get closer to where I needed to be. One summer, I attended an intensive in Georgia called Firespark. I remember waking up the morning after a twelve-hour day of technique and rehearsals. When my feet hit the floor, I could feel shockwaves ripple through my body with an ache I'd never previously experienced. As I slathered myself in Icy Hot, I kept reminding myself of my personal goal to improve.

When I returned to the studio, Kristy noticed and casually commented that my technique had really improved. She never told me I was behind, but she didn't have to tell me. Instead, she contributed to one of the greatest gifts you can develop: self-awareness.

When we performed our senior dance to Vitamin C's "Graduation Day" in our long, white lyrical dresses with puff sleeves, I knew an era was coming to a close, but I was grateful it happened because I learned so much from this woman and the exceptional people she brought together. When Kristy passed away in 2018, it hit harder than anticipated. I often find myself

going back through our Facebook chats and reading her inspiring words. She embodied joy without judgment while always setting an expectation of excellence. I strive to do the same.

Being a part of any cast or community is a tremendous experience. When I arrived in Raleigh for college, I longed to find the connection I'd found through theater and dance in Tennessee. In my college years, I volunteered and worked with any and every studio or show that needed an extra hand. This segued into producing shows for my own studios.

While I immensely enjoyed this process, it was a different kind of experience because I was a producing artistic director versus a creative artist. That was the right move to strike a balance with the business, but I missed dancing and choreographing. I wanted to jump in and be a part of Raleigh's thriving, local community theater scene. It would be a new challenge that would also contribute to the next step of my personal and professional development, serving as a win-win for the business's growth and development.

This was much easier said than done.

I applied for years to choreograph, direct, or be involved with community theater shows. No one ever told me no; they just never responded. I would let shows use the studios for rehearsal space in hopes that an opportunity might eventually present itself. I was basically waving my arms in the air and yelling, "Hey! Pick me!"

In 2013, my first opportunity to choreograph a show came in the form of the musical *Aida* with Athens Drive High School. This offer excited me so much, and I treated it like I was about to make my Broadway choreography debut. I workshopped

my choreography on dancers from the studio and set the bar incredibly high for the cast, many of whom had never received formal dance training. They rose to the occasion, and we created something beautiful and amazing. I attended every single performance because I loved the process so much. I didn't want it to end.

After the show closed, I remember sitting in the bathtub crying, convinced I would never be asked to do something so wonderful and amazing again. This felt like a major end, and I wanted it to be a beginning. I thrived on the excitement of the process and loved the balance it created with my day-to-day responsibilities at the studio. It sharpened my teaching skills and honed my creative mind. I was able to think about the art without it being tied to the business piece, and that was refreshing.

My work spoke for itself. My credibility and passion would lead me to work on a number of shows between 2013 and 2020 (thirty-five, to be exact), which would stretch my creativity in ways I hadn't imagined. I experienced the power of community with no ulterior motive other than working together to create something that others could enjoy. What a truly beautiful concept.

The stories we told onstage also brought me closer to knowing and understanding the cast of characters who comprise my world offstage.

These people, places, and chance interactions are the bedrock of handling horrible things. They remind us who we are, how we got started, and where we want to go. They transport us to simpler, less consequential times, gently nudging us forward and helping us stay blinded to distraction. When the horrible

happens, our mind returns to moments and memories that matter. The lessons we've learned. The experiences that shaped us. The people who believed in us and stood by our side. All of the above are fragments of that picture.

If you haven't recently done an inventory of those components in your life, I highly recommend it. In college, the Park Scholarship Program called it our "Plan of Professional Development." Back then, it was dreams and goals. Where did we see ourselves in five or ten years? I still ask those questions, but I also reflect more as I realize that I have brought many of my goals to life. I ask, "What got me here?" and "Why do I choose to keep going?"

Experience and success are complicated. Both are great, because you're learning and improving, but you're also climbing a ladder that expects you to only go up. When you miss a rung or slide backward, societal perception is brutally unforgiving.

The chaos can often happen at the worst possible moment. What will ground you, save you, and keep you focused? You. This includes your history, your experiences, the people in your life, and the realization of what sets your heart aflutter.

It all prepares you to handle the highs and lows that life will present. Because like the adage "the show must go on," life must also go on.

Chapter 3

THE ROLES WE PLAY

"Above all, be the heroine of your life,
not the victim."

—NORA EPHRON

BETWEEN 2013 AND 2016, I ran a blog and online resource
for dance educators called The Dance Exec. When it started,
consulting and masterminding wasn't as trendy as it is now.

I created the site because I wanted to push myself to be
better, and I was hopeful that my ideas would also help others.
Every day, Monday through Thursday, I'd release a new post. I
did this for three and a half years, and in the process, I learned
a lot about myself and our industry.

There's one graphic we used on the site that listed a few of

the roles a "dance exec" might hold:

- Dance Instructor
- Choreographer
- Costumer
- Director
- Counselor
- Supervisor
- Educator
- Financial Planner
- Role Model
- Student
- Motivator
- Artist
- Publicist
- Producer

I'm not sure this even captures the many roles artists play within our industrial duties. These are our professional responsibilities, so what happens when you add personal labels to the mix, as well?

These are the routine roles that keep our households moving:

- Cook
- Rideshare
- Laundry Specialist
- Housekeeper

- Dog Walker

- Pantry Filler

- Holiday Magic Maker

- Family Coordinator

- Vacation Planner

- Accountant

And then, we also have the major, life-defining roles. Here's my list:

- Wife

- Mom

- Family Member

- Role Model

- Entrepreneur

- Philanthropist

- Author

- Speaker

- Scholar

- Divorcee

- Orphan

These labels carry weight.

What do we do with the weight, and how does it impact our identity? Do we allow external influence to impact the labels, or are we able to stand our ground and hold control over our narrative?

The societal labels can force us to feel lost, overlooked, or wedged into a corner based upon expectation and circumstance.

In upper elementary school, I was excused from the classroom for Mother's Day activities. I don't really know why, but my heart tells me the instructors must have felt this might be triggering or uncomfortable since my mother had recently passed away. I can't blame them for not knowing what to do, but in retrospect, I'm not sure this was the best, most inclusive solution. It felt like even more attention was placed on my tragedy, and it made me feel like an outsider.

The labels can also make us feel unfairly judged.

When I was going through a divorce from my first marriage, there were many wrongful assumptions made. I sat in discomfort for a long time because of these judgments. I never knew how to publicly address questions, so I stayed quiet. It was a taxing period of time because it seemed like third parties were the most curious in wanting to know everything that was happening.

These periods where we spend time on the outside of the "norm" remind us of our unique journeys. We all carry our stories and journeys differently, but sometimes that can be hard for others to understand and accept.

As death took away many immediate members of my family, traditional holiday and life celebrations started feeling different. Traditions shifted. The socially aligned expectations of weddings and holidays, like Christmas, can weigh on those who have atypical familial circumstances. For those who haven't experienced such loss, it can be hard to understand those choices.

I often wonder if the societal expectations of our labels create more heaviness than they deserve. What if we allowed ourselves

to confidently sit in our own peace and narrative? Too often, labels, projected or self-imposed, force us to lean into truths that are counterintuitive to our path. Because of our concern of outside perception, we can compromise our mental well-being and happiness to appease those around us. It is easier to sacrifice ourselves than risk upsetting someone else.

With time, I've realized the negative weight labels evoke is usually self-imposed. We can serve ourselves and others, and it starts with owning our emotions and our self-awareness. Then we can open ourselves to prioritizing the labels with which we most identify instead of prioritizing others' reactions and responses to our roles.

Aside from my personal discomfort, my professional obligations are often high-pressure and high-stress. You wouldn't assume that a life in arts entrepreneurship would be so intense, but if you check the lists of rankings for the most stressful, grueling, and physically impacting careers, dance, choreography, and varying forms of the arts are almost always on lists.

The stress used to be all-consuming and would impact my home life, my nonexistent "down time," and even the lower stress, fun components of my professional life, like teaching a dance class. While the consumption was rooted in a place of care, it was not healthy or sustainable. There shouldn't be emergencies or crises in a performing art, like dance, and I'm learning to lean into that belief to generate greater health and happiness for my life and for those around me.

I've heard the comparison that the roles we serve are like buckets. We want to fill them all to the best of our ability, but we only have so much bandwidth. We have to know which

buckets impact us, positively or negatively, so we can decide how to create balance in our lives, whether it be through delegation, deletion, or intentional determination.

Psychology Today defines compartmentalization as "a defense mechanism in which people mentally separate conflicting thoughts, emotions, or experiences to avoid the discomfort of contradiction." Compartmentalization is a tool that I'm learning to use, when needed. At times, it's a necessity. Otherwise, how can you enjoy a trip to Kiawah Island when the state continues to mandate your business closed? Or, how do you handle the tumult of staffing issues while enjoying your child's first year of life? These are prime examples of the Business Owner versus Wife and the Business Owner versus Mom labels hitting each other head on.

Once I had a greater understanding of my roles, expectations, and commitments and how they intertwined, I became better at all of them. There are still areas where I can improve, but as long as we view our growth as a work in progress, we march forward.

We cannot underestimate how these labels contribute to our value, perception, and understanding of the most important label of all: our sense of self. Be mindful of your voice and needs as they pertain to your varying roles in life and allow them to guide your way.

FEELING WHAT YOU FEEL

It is important to feel what you feel while still experiencing the beauty, joy, and opportunity of the world around you. One day, you may be full of optimism and positivity. The next? You may

be much more pragmatic. The day after that? You may be ugly crying, maybe for no reason at all. Experiencing emotion is good.

If there's a day you need to blast your heartbreak song? Do it.

If there's a day you feel like dressing in bright, rainbow colors? Go for it.

Need to talk through a situation to feel better about how to handle it? Call a friend.

Ready to pull the trigger on an impulse text or email? Sleep on it.

And when you feel panicked or reactively urgent? Breathe.

It always pays to breathe through the pressure. Five counts in, five counts out. I learned that technique in 2017. Turns out, I didn't breathe when I was upset. When stress feels insurmountable, breathe through it. It will pass.

YOUR SELF-IMAGE

The way we perceive and project ourselves physically, mentally, and emotionally is essential in caring for ourselves. In the performing arts, this can be difficult because our institutions have historically emphasized the importance of physical appearance. We are conditioned to push through any circumstance or demand, even if that means at our personal expense.

Leotards are made for the "ideal body shape." Dancers count calories in the back of their minds as they stare at the mirror for hours on end each day. We are told to fight through the pain, push through the injury, and keep the show going. When you're immersed in this mentality, it feels normal, but it's anything but normal. It's an ingrained paradigm that we must shift.

Recently, there's been a movement to correct the entertainment industry's missteps relating to image and inclusivity, but the work is only beginning. I've watched eating disorders consume friends and family, and long-term injuries have benched friends and students.

Personally?

In the early days of the studio, I had my hair styled into a pixie cut because I didn't feel like people were taking me seriously. I was young, and clients loved to challenge me. I thought that cutting my hair would make me appear older and wiser. After six years of short hair, I decided it was time to grow it out. My lack of confidence and desire to influence others' behavior made me alter my appearance. When I realized I made this decision for others, I was taken aback, and honestly, somewhat disappointed in myself.

More recently, I struggled with the transformation of my body during pregnancy. As dancers, we know our bodies really well, and while the pregnancy transformation is miraculous, it is equally unfamiliar. Every day of pregnancy, I was nervous about what the next day, week, and month might have in store. The unknown was unnerving. My therapist reminded me that this was not a healthy mindset, rooted in a need for control. The pandemic, a time when everything felt very out of control, had likely intensified my emotional reaction to this very natural process.

The trigger point was always stepping on the scale at my routine prenatal exams. One day, the number on the scale made me feel so distressed that I cried the entire day. After that day, I acknowledged that this was a toxic behavior, and I committed

to self-work. This included working towards acknowledging my headspace, which helped me stay present in the process.

Through my nonprofit, Girls Geared For Greatness, I know that my qualms with self-image are not singular. This is something that impacts society more than we can possibly imagine. By sharing our stories, we realize we are not alone as we continue to work towards individual self-improvement and collective gender progress as a society.

Instead of image, I aim to focus on health, routines, and moderation. To live the life I desire, I need to be strong. I aim to have a healthy relationship with my self-image. I believe we can do that through recognizing the issue, the trigger, and the resulting behavior. Checking in and acknowledging your feelings are key in keeping it copacetic.

IDENTITY

There's a moment in the musical *A Chorus Line* where the ensemble extends the length of the stage, in a line, and holds their headshot over their face. The moment is moving because it questions whether the characters are authentic to themselves or becoming one with the listings on their resume. This is a question we all have to consider.

Does our work form our identity, or does our identity direct our work?

This is perhaps one of the most important questions in this book. I can look at every position I've held and recognize how my identity pushed me into the position. With each role, there's the common thread of the arts. When I ran the Arts

and Crafts Summer Program at the local Boys & Girls Clubs, I learned communication and visual arts. When I tutored for the Autism Society of North Carolina, I took my students to see an all-county production of *Aida* presented by the Wake County Public Schools. When I worked as a nanny, we were always dancing and listening to show tunes, and several of those children, now adults, are involved in dance and theater to this day.

And does our actual self represent the facade we project to conform with societal expectation?

I always wrestled with the formality of the name change that traditionally accompanies marriage. In my first marriage, I never legally changed my name. I tagged the married name onto my maiden name for pomp and circumstance; a stage name, if you will. It never felt right, like an outfit that doesn't quite fit. I'd question my monogram, would quizzically look at the lengthy letters on playbills, and spend a lot of time wondering why we expect someone to shift their identity.

What if I found identity in my name and wanted to keep it as it was given?

In my current marriage, I decided to keep my maiden name. My position isn't rooted in some major platform or argument; it just wasn't for me. I like keeping Hamilton because it serves as a lasting tribute to my mom and dad.

When we think about our identity, we have to figure out what works for us, even if it contradicts what everyone else is doing. If we are acting out of fear of disappointing others or breaking traditions, we risk sacrificing ourselves.

We have the power to choose whoever we want to be. I'm working to be a person who matches the information about me

on paper, online, and in person. Along the way, I've wrestled with my quirks, but I've also realized they are what make me unique. Instead of trying to fit in, we should celebrate those who take the initiative to stand out.

GET IN THE GRAY

While we may wish that life was black and white, most of life is lived more in a muddled and messy gray space. It's open to interpretation, research, and educated guesses. You can plan until you literally can't plan anymore, and someone or something that you didn't anticipate can still wreak havoc.

Cleo Wade makes a great observation:

> *The ego thinks we work on ourselves in order to control circumstances. It thinks that if we can do "all of these things right" then we can escape hard days by outsmarting them or being so perfect, we don't deserve them. Life is always happening. It is something we move with and through, not something we attempt to overpower.*

Control is a facade that doesn't exist. The sooner we allow ourselves to release that need for complete control in the roles we serve, the more free we will be. For me, that's tough. I'm a textbook Type A planner. But, all of the planning and controlling I've tried to do in the past has often backfired. It doesn't work. Stuff still goes awry.

So I sit in the gray and plan what I can, while maintaining preparedness for literally anything.

In 2009, I was days away from opening our first location.

I was so excited I was nearly levitating. Our phone rang, and I saw it was the cell phone number of an incredibly successful competitive dance studio owner. Naively, I figured she must be calling to congratulate me on the opening. Maybe she'd even send flowers!

I answered the phone, and she immediately began scolding me, "Who do you think you are opening your own studio?!" I was speechless. I literally did not know what to say. Once upon a time, I'd interviewed for a position there and was rejected. I stupidly said, "I didn't know it would upset you."

I'll never forget her next words, "Not knowing is not an excuse."

Click.

That phone call left a taste in my mouth, but beyond that, it gave me a lasting dose of wisdom: not knowing is not an excuse.

I stay informed, listen to the information, and make my decisions in my varying roles based on a balance of perspectives. It's a good way to stay in the gray. It allows you to "see both sides."

Over the past two years, this has especially served me well, as I added "public health official" to many of my day-to-day labels. During the pandemic, we required masks at the dance studios. It seemed to prevent in-studio spread based on our tracing and experiences, and it was a mandate in our area. Still, people would strongly disagree with these choices. I just wanted to keep our doors open, and it was frustrating to be evaluated on public health policy instead of dance education.

During this time, I was stretched beyond my expertise, but I stayed in the gray, listened, and maintained my commitment to the safety of the collective. Decisions can be bigger than

oneself, and I try to take the macro approach as my approach to leadership. When the mask mandates started falling away in March 2022, I felt unexpectedly emotional as I removed the signs from around our building. It felt like it might finally be possible to reinvest my focus into my actual career instead of this unforeseen, extreme disruptor of COVID-19.

AUTHENTICITY

Authenticity is a rare unicorn trait that will make you stand out in today's world of influencers, imitators, and imposters. In 2018, I directed a youth production called *Alice @ Wonderland*, and in my research for the project, I learned a lot about Lewis Carroll and the classic story.

The following quote stuck with me: "'You,' he said, 'are a terribly real thing in a terribly false world, and that, I believe, is why you are in so much pain.'"

The world suggests we should push ourselves towards being an influencer, but the power of impact actually lies in being influential. Influence makes us crave something shallow, whereas influential stories give an aspirational goal.

I am a part of a rare, predominantly female-led industry. My staff is currently 100 percent New Majority, a label that encompasses people of color, women, immigrants, LGBTQ+ people, veterans, and the physically disabled. Our beliefs and values represent a full spectrum of ideology, and we are able to collaboratively work together to push our goals forward. Instead of that setting us apart, it leverages us to achieve greatness.

Through this small ecosystem of arts entrepreneurship, we

model an opportunity for a functional society. Understanding (and listening) to others improves our authenticity in our positions, which boosts our leadership potential.

I'm a watcher, an observer. I rarely walk into a room and immediately start firing off. But when I'm a part of something I care about, I will use my voice. When I was much younger, I stood up and expressed my opinion in a board meeting for a national-level dance organization. After the meeting, a person I admire came over and said, "You're quiet and demure, but you're smart as hell. Use it."

Growing up, I had a speech impediment and an Eastern Tennessee accent. Neither should influence a person's perception of someone, but unfortunately, that's the world we live in. I worked hard to get rid of the impediment and the accent. You will rarely hear me say the words "war" or "dwarf," and I think twice when I enunciate "ice" and "idea."

A successful tenure in middle school public speaking contests helped me find comfort and confidence in my voice. It might sound like the nerdiest extracurricular activity to embark upon, but public speaking is one of my strengths. I'm grateful I was given the opportunity to find love and comfort in something so many people fear.

My intellect supports my voice and has given me the tenacity to hustle in my field with extreme focus. I mentioned it earlier, but you'll never hear me say the four-letter word "work" because it suggests a laborious act. If I'm being true to my most authentic self, I have to recognize the power of being called into this field and using my talents to serve in every way possible.

Many years ago, an Instagram account called "Spirit Science"

posted the following meme. I saved it because it resonated with me: "Confidence isn't walking into a room thinking you're better than everyone, it's walking into a room and not having to compare yourself to anyone at all."

Your authentic self has a gift to give the world in each and every role you play. Don't silence it simply because someone says you should look, think, talk, feel, or act a certain way.

VULNERABILITY AND REPRESENTATION

Equality is a work in progress. When I was younger, I wanted to be viewed as an equal in everything: in business, in theater, in life.

A recurring frustration is the general public's underestimation and discrediting of the dance education industry.

Over the years, I've heard the following played on repeat:

- "Oh, you run dance schools? That must be fun."

- "What do you do all day since you just run the studio at night?"

- "It must be nice to have all of that free time and get to do whatever you want."

Yes, I run dance studios, but above and beyond that, I'm an entrepreneur and a businesswoman with annual gross revenue that puts me in the top 5 percent of women-led businesses.

With age, I become more aware of the patriarchal systems that create red tape for our success. These preexisting assumptions can be combated with honesty, authenticity, and vulnerability. Education is key.

When I was working on my TEDx talk, we would practice

in front of panels to gauge feedback as my curator and I fine-tuned the final product. This was a detailed process that taught me a lot about myself and the power of storytelling.

One part of the talk focused on our 2019 recital performance. The morning of our recital day, the venue lost power. Our shows, brand, client satisfaction, and budget were all on the line. One of the panelists raised his hand and said, "I don't get the big deal about this show piece. Couldn't you just reschedule and move on?"

If you've ever worked with venues, you know it isn't that easy to simply reschedule. If you've ever produced a performance, you know it also isn't that simple to reconvene large groups of people for a specific, celebratory occasion with a strong emotional investment. Show budgets aren't small, and there's generally a lot weighing on the success of the performance.

Prior to responding, I took a beat. I told him that I appreciated his question, but with all due respect, I didn't feel like it was a question that would be presented to a speaker in a tech or startup field. The room went quiet because I was right.

In the arts, even when we feel vulnerable, we have a duty to show up, speak up, and educate others about the power and purpose in what we do. Take your place at the table alongside every other esteemed industry, and don't shy away from the major, positive impact and contributions we have on society.

DOING BETTER

With the responsibility of educating others, we have to recognize the same opportunity within ourselves.

In the early days of the studios, it took time to determine

our culture, leadership style, and systems. When I produced The Dance Exec Seminars for other dance educators, I would share our staffing systems. At a Charlotte event, a studio owner from Myrtle Beach, South Carolina, sitting in the front row, questioned if one of our staff evaluation tools was a bit "micromanage-y."

Initially, I was taken aback. I felt called out in front of a group of people that I was supposed to lead. I couldn't shake the question, and after a lot of thought, I realized the tool was micromanaging. It was put in place because there were people on our team who were not a great fit for our culture. This was the defense mechanism I employed to combat my own shortcomings as a leader, and as a result, the entire organization suffered.

When there's an issue, it is always easier to confront it head on. Tiptoeing around it in order to avoid addressing the actual issue never pays off. It's patching a hole versus repairing it. Go for the full-on repair. It may require more time and energy, but it will be worth it.

STRIVING FOR EXCELLENCE

When you have standards for excellence, there's often a variety of adjectives that compliment your reputation. A desire for excellence should excite others and make them want to aim for excellence alongside you. And while it will deter some, it will serve as a beacon for the people who are meant to find you.

It was during my time directing and choreographing community theater that I was first privy to the label of "intimidating." In many ways, this label is unfair because I will come early, stay

late, and do whatever it takes to make sure everyone in my care is properly prepared for whatever task is in front of them. I will also push people to be their personal best.

Typically, I work with youth in the dance studios and in theater productions. At this point in time, I was working with adults who were bringing their own levels of frustration to the rehearsal room. There have been multiple occasions, on different shows, where adults have stormed out of my rehearsals. I have counted "five, six, seven, eight!" a little too loud a few too many times. For the people who complete the experience, the final product is rewarding because it reflects significant personal growth.

Growth represents excellence. Excellence is a process, not a product. The greatest examples of it can be found in the details.

For example, as a choreographer, that means specificity in arm placement. If you say "hands on hips," what does that mean? Do the hands go in fists or lobster claws? If the answer is fists, do the thumbs go inside or outside of the fingers? If the answer is lobster claws, are fingers connected or spaced? These are small nuances that will push a movement from good to great.

If this commitment to detail is maintained in any field, excellence becomes a habit in practice versus an occasional victory.

Excellence is not perfection. Perfection is something I used to try to achieve, but during the pandemic, I realized that continual creation, motion, and correction is more important than perfection. It was a time when I used trial and error in abundance. The perfect time, product, solution, and scenario didn't exist. It never did, but the breakdown of our functioning society made this even more evident.

Now my metric for excellence correlates to the circumstance

of the occasion. While perfection can be a goal, it's often unrealistic and will paralyze growth. Be wary of anything that pauses you from forward motion, including the desire to be perfect.

ACCESSIBILITY AND ACCEPTABILITY

Dance and the performing arts have the capability to be one of the most inclusive and connecting forms of community we can experience. As we work towards improving ourselves and our institutions, we have to look at ways we can improve our understanding of community.

During the pandemic, I had an incredibly transparent phone call with a studio owner in another state. She was curious about my ability to maintain political neutrality while balancing oppositional views regarding public safety protocols and procedures. Our ideologies in approach were very different, and we were dealing with differing levels of government mandates. We were both frustrated with the fact that our programming was being judged not on the value of our dance education experience but on the issue of whether or not masks were required.

The responsibility of public health mitigation that was placed upon small business owners weighed heavily on me. It was a source of constant anxiety, as every choice I made could impact my family's livelihood as well as job opportunities for my staff and the long-term sustainability of my businesses. Without students, you don't have a studio, and with so much conflicting information, I could never be certain which choice was the right one. Who would stay? Who would go?

My anxiety reached a tipping point in the summer of 2021. We were losing clients due to our safety protocols, and I was concerned I was overreacting. I reached out to a friend from college, a biologist who had been very vocal and proactive in offering advice to everyone from the beginning, and shared my situation and concerns.

She agreed with my positioning and posed the question, "What can your conscience live with?" After a few hypothetical scenarios, I knew that my approach was the best approach for our institution.

From our conversation, an important quote emerged: "We have a duty to our community even if we are just here dancing together."

This phrase reaches beyond the pandemic; it includes:

1. Accepting every participant as they are.

One Christmas parade, many years ago, our sound technician (a performer himself) was overcome with the hype of the festive environment. He started dancing and bringing his A-game performance. It was amazing, and the crowd was feeding off of his energy. A few days later, I received an email from a stranger thanking me for featuring inclusive gender and body positive representation.

The emails that have helped us realize the importance of dance for all is humbling. Different hair types may require different hairstyles. We can accommodate gender preference for costumes and dress code to make sure each person feels

comfortable and confident during their time on stage and in class. We can listen and provide more inclusive options when it comes to skin tone shoes and tights. Anything that leads to more people being involved in the performing arts is a win. If it has only been done one way in the past, that doesn't mean there's not a better way to do it in the future.

2. Encouraging acceptability and breaking down stereotypes.

In preaching acceptance, we also have a heightened accountability for follow-through. Your inclusivity may lead the way and others may not be comfortable enough to lean into the process.

We once had a physically disabled student who was an incredible dancer. There was a student in the class and her adult representative requested that the child not stand next to the disabled student. I was so shocked I could hardly comprehend what I was hearing. After explaining our position of inclusivity, we excused the family requesting the modified spot.

When we set up tables at varying festivals and expos, we interact with lots of people. We are located in North Carolina, and there's a troublesome mentality that dance is not acceptable for boys. I've even had male staff members or alumni working the booth and passersby aggressively proclaim that dance is not for boys.

What do we do?

We keep moving forward, educating and promoting inclusivity while focusing on hate-free acceptability. That's who we are, and that's what we will stay committed to doing.

BELIEVE IN THE BEST

Mental toughness is a necessity—for the arts and for life. If you're going to maintain your roles and create an environment where you can thrive, you have to guard your mind, soul, and body. You have to do the same thing when you're performing a demanding role or have creative responsibilities.

You are mentally strongest when you are physically strongest. This strength will help you navigate and cope with any challenge thrown at you in regard to any of your labels.

In 2020, John and I decided to start seriously shopping for a house in Raleigh. I had successfully handled several real estate transactions in the past including buying and selling two condos and my parents' estate in Tennessee. I didn't think there would be an issue with the process. With the birth of our son on the horizon, time was of the essence. People would constantly ask, "When are you going to get a house? You aren't going to raise your child in a condo, are you?"

We put several offers in, all way above asking price and with solid amounts of due diligence on the table (due diligence is an oddity specific to North Carolina). I even wrote a couple of real estate love letters. This felt cringey but showed our commitment to the cause. The best we ever got? Fourth place. We were starting to feel the reality of bringing our baby home to a 984-square-foot, third-floor walk-up condo.

We tabled the stress of the quickly escalating real estate market through the end of that year. Later in 2021, we were ready to get back in the game. We found a townhouse we loved that was in the perfect location. When I went to get our

prequalification letter, I was told that we didn't qualify for a mortgage, even though we looked great on paper.

The reason?

I was self-employed and cut my salary in 2020 to keep the studios afloat. The mortgage companies deemed this unacceptable and had basically frozen my eligibility as a self-employed person that showed a drop in income between 2019 and 2020.

I cried a lot of ugly, gut-wrenching tears over this situation. I had worked incredibly hard with tremendous amounts of self-sacrifice to be told that an institution deemed me an unfit candidate to purchase a home. Wasn't this the "American Dream"? It felt so unfair when my bank account, credit score, and history all showed "Excellent" in every category. It felt unfair that I had kept my businesses going and rents paid when many had given up.

I would scroll opportunities on Indeed and through Arts Consulting Group, wondering if a salaried position might be necessary to adequately contribute to the needs of our family.

Then the mental toughness kicked in:

My profession matters.

My value exceeds the amount of worth on a piece of paper.

I will not apologize for the way I chose to lead to keep our community intact during a very tough time.

The house will come.

The turmoil of this process and experience made me realize the importance of our confidence in our decisions. Are there things I could have done differently in 2020 that would have given me the papers to qualify for a house in 2021 before the housing market went absolutely haywire?

Potentially. But they would have required significant layoffs, which would have impacted our programming, community, and longevity.

I know at least two other self-employed, highly successful female business owners who encountered similar scenarios.

When things feel unfair, maintain confidence in your work. When the systems of society challenge your worth, stand strong in your optimism and authenticity. It will pay off.

Throughout life, there are going to be people and places that challenge your labels, your worth, and your place in the world. Sometimes, it will even be yourself. Knowing who you are and protecting your priorities will enable you to navigate these challenges.

Whenever I'm having a rough day, I remember a label that's not on my official list. My friend Brad affectionately refers to me as "The Beast." If you know me, my outward projection does not immediately fit that title. But my inner self is wired to hustle hard, strive for greatness, and encourage those around me to do the same.

Beasts aren't born; they're made. After my parents' death, my aunt made this her mission. She had no kids of her own and went all-in to give me as much of a normalized life as possible. Between her dutiful upbringing and my passion for dance, I was destined to be a disciple of hard work and success.

This foundation has made me strong, laser focused on my goals, and capable of whatever storms blow my way. So whenever I'm struggling to maintain whatever role is required of me at the time, I remind myself that I am a beast.

I believe we all have a degree of inner beast in us. When you're wrestling with how you fit into it all, keep in mind that we all struggle with feelings, image, identity, the unknown, authenticity, vulnerability, progress, excellence, adaptability, and optimism. The kinder we are to ourselves, the better we will be able to handle and cope with whatever comes our way.

Chapter 4

THE BREAKDOWN

"I'm always perpetually out of my comfort zone."

—TORY BURCH

THERE'S A NERVOUS energy that accompanies a life well-lived. Whether it is a tension in the jaw, butterflies in the stomach, or a general readiness for "What's next?," people who perform on stage and in life are typically ready for anything.

When Lainie Munro isn't performing around the world, she's a dream of a dance teacher. With her petite stature and fiery red hair, she starts each class with a motivating, handwritten quote that she tapes to the mirror. Her classes are full of SHAs, chants, and combinations that will leave anyone feeling like a rock star.

In 2012, Lainie visited Stage Door Dance as a part of our

Summer Intensive. At these events, the staff and guest instructors enjoy dinners after the classes where we have time to connect, reflect, and socialize. I'll never forget how she articulately described the pain and pleasure of life. She compared it to a series of hills and valleys, comprising every range of the emotional spectrum, including the highest of highs and the lowest of lows. Raising her glass of wine for a toast, she matter-of-factly declared, "This is why we know how to live."

In the performing arts, the hills and valleys of our personal and professional existences don't necessarily have clear-cut boundaries. We live for our work, and our lives mirror that passion. Personally and professionally, we have this innate calling to something larger and greater than ourselves, and I've witnessed this level of conviction from amateurs to professionals.

This visceral hunger is arguably unique to our industry. We can't wait for the next opportunity or gig, because we know what it feels like to have that void of uncertainty. We also know that our opportunities are reliant upon our bodies being healthy and free of injury. That means there's no clocking in or out. When we aren't actively engaged in our art, our lifestyle is built upon honing our craft, our skills, and our sustainability.

The temporal nature of performance creates a sense of urgency that ushers every person onstage, backstage, and behind the scenes to rally for the greater good. Shows end, our opportunity to get it right is short, and we can never take one moment of any of it for granted. This goes for educational performance, professional performance, business, and life.

In late 2021, I had my own communication code for

identifying hills and valleys, as I'd casually answer the phone, "Is it a crisis, or is it chill?"

It was my way of triaging situations. So many things had happened, and I needed a way to preempt the direction of each encounter. It was helping me stay grounded and calm.

I used the following factors to triage each "crisis or chill" scenario:

1. **SITUATION.** What are the facts surrounding the occurrence?

2. **PERCEPTION.** Who is the person assessing the situation and relaying the information?

3. **PROJECTION.** Does the messenger's personal attachment to the message shift the way the scenario is conveyed?

4. **RESPONSE.** Is the person involved in the situation able to clearly communicate with limited bias?

By using these four questions to cipher through situations, many problems will fizzle out into much smaller issues. They're "chill" and can easily be de-escalated. These types of concerns stem from a frustrating day, a misunderstanding, a hurt ego, or exhaustion and fatigue. That's not to invalidate the feeling surrounding a situation—those are real.

Rather, it challenges you to statistically weigh if the energy towards the issue matches the gravity of the problem. Conflict produces pain. It's the conversation we don't want to have, the answer we don't want to hear, or an inconvenience that interrupts our day. Cheryl Richardson said it best, "If you avoid conflict to keep the peace, you start a war inside yourself."

Allowing an internal war to erupt is not the form of self-care we should practice. We often opt for this because we are so fearful of hurting others. We would rather martyr our peace than make someone else feel uncomfortable. Sleepless nights, tense jaws, anxious pits in our stomach are universal commonalities in sacrificing our personal well-being.

The Pareto Principle suggests that approximately 80 percent of our consequences come from 20 percent of the causes. For example, if you have a loud minority of problematic staff or clients, that is undoubtedly going to monopolize the majority of your time, energy, and resources.

Prior to exiting dance competitions, our competition team was the perfect example of a major imbalance. We reached an insufferable point where changes had to be made. This is a frustration we could have alleviated much sooner, and my one regret in managing that transition is that we didn't do it faster.

If something is creating pain in your life, rip the Band-Aid off. Protect yourself.

There are shades of darkness in the valleys, and our self-awareness in how we identify and process moments of conflicts guides us closer to our power. Emotional conflict is a process, and it can show up in a variety of forms based on many factors.

By identifying and labeling different types of emotional pain, I've found it can be easier to navigate.

DON'T SWEAT THE SMALL STUFF

In 1997, Richard Carlson wrote a wildly popular book called *Don't Sweat the Small Stuff, and It's All Small Stuff.* To me, the

small stuff represents the conflicts and chaos that we get hung up on when we shouldn't. It's misplaced energy because, more than likely, in five years, it won't matter. Small stuff includes irritants, short-tempered moments, judging others, and random situations that get our tinsel in a tangle for seemingly no good reason.

It's showing up at the airport at 6:00 a.m. for a 6:40 a.m. flight and the ticket counter tells you it is too late to check your bags. Begrudgingly, you settle for a later flight and buy a book or some overpriced airport breakfast to pass the time.

It's the end-of-year Recital Grid Master Document you know you saved on your computer. It took hours to create, and you resisted using Google Drive when everyone told you to transition out of using Microsoft Word. When you log back in, it's gone and completely unrecoverable. You cry, are frustrated, and vow to never use Microsoft Word again.

It's the missed call you receive from a number you don't know. You agonize about who it could possibly be and why they didn't leave a message. Reverse lookup doesn't show anything, so you ponder who or what could have called, allowing the mystery to disturb your peace.

In performance, it is the missed cue, forgotten move, left-behind prop, or costume disaster. During our competition days, we had an Elvis Presley production number that I envisioned being something truly spectacular. The vision and the execution didn't quite match up. Midway through the piece, one of the Elvis characters rolled out on a small wooden platform with adoring "fans" surrounding the platform. At our first competition, the platform didn't roll and was a complete disaster. I cringe thinking about it.

At the end-of-year recital performance with that same piece, Will was six years old and played our youngest Elvis character. Right before going onstage, he had to use the bathroom. As he was finishing, he accidentally dropped his Elvis wig in a urine-filled toilet, panicked, grabbed the wig, and put it back on his head. When he went out onstage, the wig was on backwards, dripping in pee. He's gone on to perform in a number of Broadway shows as well as film and television, and to this date, we still laugh about this memory.

Speaking of performance memories, in high school I was dating a guy, and he was a tremendous trumpet player. For my high school piano recital, I invited him to duet with me on a performance of "Memory" from the musical *Cats*. I did not practice my piano part nearly as extensively as he had practiced his trumpet part. I figured my right hand would keep going, even if my left hand fell behind. At the very least, I'd hold the melody.

Shortly into the piece, I lost my place in the music and stopped for a few measures. Instead of trying to get back into the duet, he kept playing the entire piece, without me. At my recital. I was mortified, crying, and angry. As I type this story out, it is hard to contain the giggles because it seems so silly. But, I will tell you: I never showed up that unprepared again.

Aristotle might have said it best when he noted, "Suffering becomes beautiful when anyone bears great calamities with cheerfulness, not through insensibility but through greatness of mind."

All of these superficial examples of frustration usually pass quickly. They get filed under annoying inconveniences that

may one day turn into a giggle. They're fleeting, and we need to be purposeful in treating them as such.

DIFFICULT DIALOGUE

Having difficult conversations is more complicated because there's not merely frustration; there's a debate or differing perspectives that make us question our thoughts or actions.

When I first arrived in North Carolina, I wanted to find a dance studio that felt like home. I enrolled in a program called Broadway Dance Project's Pre-Professional Program. The program promised opportunities, but outside of classes, we only performed at the nursing home and in malls. While this is great for educational experience through high school, I was in college and eager to take my training, experience, and exposure to the next level.

It wasn't for me.

In April of that year, I prematurely left the program. I explained why, but the reasoning wasn't well received. A few months later, I felt guilty about the way I handled the exit, reflecting on how I could have finished the final few months of the season or approached the situation differently. I wrote an apology letter. At eighteen years old, this felt like a tremendous step in taking ownership for my response. My heart deflated when I learned the letter was received, read publicly to the company, and mocked.

Moving forward, I decided this scenario would not deflate me, but would remind me to find compassion in conflict and discomfort. Life is best lived not in opposition but in collaboration.

When disagreements and conflict arise, how can we view the positioning of each party in a respectful and humane way to bridge the gap of understanding?

In thirteen years of leading the dance studios, I have learned a lot about listening and understanding the positioning of others. I have learned to listen to hear versus listening to respond. This has been compounded through my love for theater, which I'm convinced is the single greatest tool in existence for teaching empathy. There have been many times where I've walked out of theater, hungry for more knowledge and understanding about a situation, story, or a character's psyche.

As an example, *Miss Saigon* and *RENT* are musicals that engage in social commentary sourced from the operas *Madame Butterfly* and *La Bohème*. Similarly, *West Side Story* and *The Lion King* use Shakespeare's *Romeo & Juliet* and *Macbeth* to develop their plot.

The point?

Stories that were relevant hundreds of years ago are able to be adapted and retold in contemporary settings. It resonates both then and now because the human experience is timeless. If we carry that knowledge with us in our daily lives, we gain a tool to help us navigate conflict that derives from differing opinions. This same concept can be applied to our everyday conversations and interactions.

In the early days of the dance studio, we received a not-so-flattering Google review where the reviewer labeled the dance studio as a "ma and pop institute." This wasn't how I wanted to be known, so I was insulted. Scared but determined to not fall victim to the falsification of this label, I called the

client. Surprisingly, we had a very respectful conversation. The client was frustrated about a misunderstanding in communication regarding the end-of-season recital. Instead of reaching out, she lashed out because she felt uncomfortable, too. At that moment, I realized I assumed our clients would have an understanding of the performance process, which was ignorant on my part. Simply because I had familiarity did not mean everyone would share that sentiment.

By the end of the call, the client agreed to remove the Google review, and I had a Business 101 Lesson about listening and hearing client needs and concerns. We lost the client, but I gained invaluable knowledge that heightened my awareness of how others might perceive and/or feel about information presented (or a lack thereof).

In that moment, I was determined to heighten the clarity of the performing arts experience through:

- being organized

- communicating clearly and frequently

- being collaboratively open to working together towards the greater good

In 2018, I had a deeper conversation with a client after we announced our recital theme Page to Stage: dances inspired by popular children's books. To determine the books that would inspire the routines, we vetted the Caldecott and Newbery Award Lists, both designed to recognize excellence in children's literature. This parent respectfully inquired why there were no black female protagonists featured on the list.

The only answer I had was that they weren't featured on

those lists, and in that moment, I immediately knew that answer wasn't good enough.

I was upset about the entire situation, but grateful for the educational opportunity. We can't work together or meet in the middle if we don't have the knowledge to do so. Our company strives for inclusivity, and I felt like we had dropped the ball regarding representation in this particular situation. I called several educators and discussed this with them at length. It was upsetting to learn that this underrepresentation in children's literature is a much larger, systemic issue, like so many things in our society.

From this conversation, I learned to look past what is immediately in front of us. Do the digging and find the right way to make everyone feel as though they belong. Try to see situations through the eyes of someone who may not have the same experiences as you.

Take the time to have the conversations, even when they are uncomfortable.

MISALIGNED MEMORIES

We all have moments that played out differently than anticipated. The memory may evoke a strong, emotional response. It's cause and effect, action and reaction. Sometimes, the pain happens to you. Sometimes, you create it.

It's the opportunity you thought you were going to get and didn't. Or, maybe it is the opportunity you take away from someone else. It can even be the resolution you thought you might receive for a situation or conflict, but instead of hearing one way or the other, you're ghosted.

A few years ago, I was invited to apply for an adjunct performing arts teaching position at a local university. I was excited because this felt like a great way to return to academia and apply my knowledge to a new audience and community.

I took the interview process very seriously. I created a curriculum, taught an amazing demo class, and met with the heads of the program. I felt great about it and knew this would perfectly align with my future goals as well as synergistically benefit the studios.

I started planning to be in this position before it was officially offered to me. Why would they extend a personal invitation to apply if it wasn't going to happen?

And then I got the email: "We've decided to go in a different direction with the position and will not be needing your services."

Ouch.

I've also experienced being the one to deliver this type of news.

When I was casting a community theater production of *The Wedding Singer*, I had two incredible candidates for the lead role of Robbie Hart. The creative team was divided on which person should be cast, so the final decision was left to me, the director. This put me in quite the awkward position, as I had personally extended an invitation to both candidates to attend the audition. When they were both there, I felt: (a) flattered they both wanted to be a part of my show; and (b) terribly uncomfortable because I knew I would have to reject one of them.

When the cast list was posted, the person who wasn't cast

called and texted, rightfully confused. I didn't answer because I've learned that reactionary responses generally need space.

The person whom I cast is now my husband.

Everything works out for a reason, and everything has its season.

DABBLING IN DISCOMFORT

For a number of years, I have had the opportunity to speak to the Leadership Academy of the Park Scholarship Program at North Carolina State University. A piece of this seminar offers the opportunity for program alumni to share tangible benefits of collegiate leadership training with program attendees. Every year, I feel like the threshold of what I can share intensifies.

A constant over the years has been this singular piece of advice: Stay uncomfortable.

Practicing discomfort is an art. It can be traveling somewhere new, answering the phone when you aren't in the mood, or saying yes to a meeting that you don't want to take. As we practice sitting in discomfort, we teach ourselves to be watchful for new opportunities, relationships, and possibilities. With practice, the uncomfortable becomes routine.

At one point in 2016, I remember thinking: *Is this it? Is this as exciting as it gets?* We should fear stagnation and complacency because it means something isn't going right. We aren't pushing ourselves or moving the needle in a way to reach our fullest potential.

Outside of that one, flickering moment of complacency, I feel like there's always been motion, discovery, and change, and that has kept me sharp and ready for what's to come.

In 2005, I had a taste of the big city dreams I craved. I moved to NYC with the intent of doing a semester exchange program with William Paterson University. I needed something to make me feel comfortable with the move, and that came in the form of the person I was dating.

As much as I loved NYC and fancy restaurants, I realized, almost instantly, that moving there was not the right choice, not at that time. The person I was dating was several years older than me and ready to settle down. I was nineteen and ready to be super successful. Our paths didn't match. One Saturday afternoon, I owned my mistake, packed my bags, and headed back to Raleigh, North Carolina.

Of course, I was warned that it wasn't the right move, but I didn't listen. As my aunt and I drove a Penske truck to NYC over Labor Day weekend to pick up my belongings, I sat in the discomfort of my mistake all the way up and down I-95. She never once shamed me or said, "I told you so."

I often think about how powerful it was for her to let me fail. It is important to allow ourselves the opportunity to experience and feel failure and disappointment, even if it is an antithesis to our peace. If we aren't failing, we aren't trying, and I believe trying is important in developing ourselves and our leadership.

It's one thing to stand in discomfort on your own. Nearly a decade later, when we moved the studios away from dance competitions, I had to motivate an entire institution to stand in the discomfort with me. There's a big difference in a decision impacting yourself versus the collective.

Everything we experience, practice, and encounter helps

us navigate the choices we have to make, personally and professionally. They may impact us and they may impact others.

Practice the discomfort and surround yourself with people who will lean into the discomfort with you.

THE GRAVITY OF GRIEF

All the aforementioned pain can be handled. It's cyclic. While it may create some temporary stress or discomfort, it passes. Deep pain happens to all of us, and it is the core, shaking hurt of the unthinkable. It's an irreparable loss that brings you to your knees and makes you wonder how you'll navigate another day. It's the primal sobs you can't control. It's a gap that equates to deep uneasiness during holidays and life milestones.

For me, the gravity of grief is a unique, deep pain.

During the pandemic, I spent a lot of time thinking about grief and loss. We all experience it, and for whatever reason, we act like we don't. There's so much stigma surrounding the process that we hold it close to our hearts and parade around like nothing has happened. And yet, it happens to all of us.

We act as though we are fine and everything is fine. Maybe it's because the energy it requires to think about it and discuss it is significant? Maybe it's because we've experienced the discomfort of someone who hasn't shared such an experience?

Losing my parents in my childhood was a huge, unnatural occurrence. As an adult, I've read newspaper articles that declared my dad a "hero" for being in the truck that swerved to miss the car on the bridge. In swerving to miss that car, two families' lives were torn apart as both people in the truck were

killed. My dad was only twenty-eight years old at the time, and I wasn't even two.

I've also reflected on the amount of time I spent in hospitals as my mom received treatment for Stage 4 breast cancer in the early 1990s. She never wanted me to see her pain, and as a parent, I can't imagine the horror she must have felt at the prospect of leaving her daughter behind. She fought the most courageous battle. The last time I saw my mom was six days prior to her death, at my ninth birthday party. A party attendee told me that my mom looked sick and would likely die. I didn't believe her because I didn't believe the world could be that cruel.

We lost her when she was only thirty-four years old. At the time, I was nine years old, and I remember feeling this fierce desire to be okay: for me and for those around me. While I'd grown accustomed to being adaptable over the years with Mom's various hospital stays and treatments, the finality of this situation hit me as I pulled on my black funeral dress accented in sunflowers. My parents, the people who created me, no longer existed.

The illogic of the cruelty of the world never stopped as we experienced the loss of grandparents, family friends, and special pets. I remember Grandpa Bill telling me on a car ride, one of my first times driving my 2000 black Ford Mustang, that he didn't want to leave this world. His body had quickly been consumed with lung cancer. He had filled the void of a father figure in my life, and he loved my dog, a Scottish Terrier named Scottie. My mom gave Scottie to me when she was diagnosed with breast cancer so I would have a friend to keep me company during her treatments and time away. I lost my

grandpa during my sophomore year of high school, and I lost Scottie on the morning of my eighteenth birthday.

When life is riddled with loss, we can cling to the anticipation of uncertainty of what's ahead, or we can take the pain of our loss and pour it into the exuberance of our life. For many years, I think I straddled the two, freezing out the pain of the losses while seeking a sense of normalcy for myself. You hear that there is no right or wrong way to grieve, and I believe this to be true.

There will be periods of time where the grief hibernates. Then something happens that makes it resurface. After I lost Scottie, my aunt and granny purchased a Bichon Frise, Laila, to help me acclimate to my new life in Raleigh. Laila joined me my freshman year in college, when I was only eighteen years old. She was a fiercely spirited dog, and I'm not sure whether I wrangled her or she wrangled me. We were thick as thieves. At fifteen years old, Laila started slowing down. She wasn't well, and I knew it. There had been a series of seizures, and I had to hand feed her baby food, which she often refused. The thought of losing her paralyzed me, and I would pray daily for her to pass in her sleep so I would not have to make the difficult decision to assist her in transitioning away from this world. Everyone kept saying to me, "You'll know when it is time."

And I did.

But knowing when the time is right doesn't take away the pain of the process. In losing my best friend, I stared grief in the eye in the most heart-wrenching ways.

One of my dear friends from college, Liz, captured Laila's essence in the following eulogy:

Laila was always fondly referred to as "Fluff" for me. She was a spirited ball of fur that knew how to get right up in your face and smother it with wet tongue marks, particularly on days you were sleeping on her couch. She wanted to make sure you were up and ready for the day.

Fluff was always the happy spirited fur-ball to Chasta's whirlwind of activities. Whether we were out taking her for a walk, or grabbing a milkshake for me or a Diet Coke for Chasta, "Le Fluff" was constant company. I'm not much of a dog person usually, but Fluff had an adorable way of getting you to love her no matter what. She would lounge by the pool with us and had birthday parties to rival those of people.

Despite her high end dog treats and fancy dancer assistant lifestyle, she never tired of adventure by digging through the trash, when it was accessible. She kept me company on the couch and woke me better than an alarm clock. And, most importantly, Chasta loved her to bits, and she made an effort to return that love to Chasta and all those Chasta loves.

It didn't matter how far away I wandered or how often she didn't see me, she was right there for a big wet kiss the next moment we ran into each other.

Laila, aka Fluff, you will be missed.

At thirty-three years old, I realized that I didn't have to be

as strong for others as I'd felt at nine years old. I cried. A lot. For Laila and for all of the other losses. A wave of vulnerability engulfed me as I recognized that the pain I felt was an extension of the love that we all shared during our time together.

It doesn't matter if you lose loved ones when you're young, or they're old, or it's anticipated or unexpected. Loss is loss, and we deserve to process it.

As society muddled its way through the pandemic, I kept thinking about loss and grief and picked up a copy of the book *The Beauty of What Remains* by Steve Leder. The book beautifully focuses on the power of living through loss, and I now carry Rabbi Leder's words with me each day:

"Let them live through us.

See it all for them.

Let them live in memory."

So now, when I think about Laila, I remember the day she ate over half of a Papa John's XL cheese pizza at the studio while we had a late night tech rehearsal for a dance recital. Her belly was visibly distended, marinara sauce coated her pearl white mustache, and she was, perhaps, the happiest I've ever seen her as she waddled home that night.

Or when I think about my mom, I remember the two of us freely dancing together in her bedroom to the opening credits of *Viva Las Vegas*, shimmying and shaking like Elvis Presley and Ann-Margret. She loved the arts and created Halloween costumes for me that would rival a Broadway costume designer.

I look at photos more frequently, I speak the people who have passed on into existence, and I dutifully remind myself that

loss is a universal experience. In keeping these powerful spirits alive, we remind ourselves of the greatest act of living: love.

MAKE THE MEMORIES

If there's a way to counteract pain, it is in making positive memories. Memories connect the circle of life, and for me, a lot of my best memories are tied to performance. I have a videotape of one of my early dance recitals where you can hear my aunt and my mom whispering about the moves and remembering their dance recital experiences. When performance days arrive and I see families arriving with bouquets of flowers, I remember how special I felt when my grandparents would give me bouquets of pink roses and dance-themed Precious Moments figurines. After shows, we'd head to the Bonanza restaurant and sit at tables with fifteen to twenty people sharing and celebrating the occasion. To this day, I will receive playbills and programs from family members in the mail, sacred mementos reminding us of these very special moments in time.

As lives changed and people passed, performance rituals started looking different, but my aunt and granny made a point to attend every show possible. This included our first-ever recital, a holiday show at Stage Door Dance, which happened to occur in the midst of a major snowstorm that hit their driving route between Tennessee and North Carolina. I was nervous about the show, but when I realized they'd hit intense weather, I was worried sick. I didn't sleep at all. As they sat on the side of the road, a six-hour trip turned into a sixteen-hour trip. I prayed for them to make it, not only for their safety but because I couldn't

imagine doing this without a family member in the audience.

Weary, they made it in the nick of time with a hysterical story about snow pouring into their car when they accidentally opened the sunroof. This is another treasured memory that makes the power of performance all that more meaningful.

With the dance studios, I get to watch other families have these same special memory-making moments. They have extended my family in the most incredible way. When we are all faced with the deep pain of life, I hope these memories we create will warm their hearts and remind them of the love and community they shared.

The small, medium, and not grief stuff? It's inconvenient and stressful, but it will pass. If you keep it in perspective, it becomes much easier to process and manage. Nails are going to get in our tires. We are going to leave our credit cards at restaurants and will have to update our extensive lists of autopay. We are going to have to work with difficult colleagues and clients. Our journey may disappoint or not meet others' expectations. In the midst of all of it, we live.

The things we allow to take space in our heart have to matter. Prioritization matters. That way, when the breakdown happens, in whatever form, we are readily equipped to acknowledge and address the event and move on with life.

Chapter 5

THE BUILDUP

I BELIEVE IT was Isaac Newton who suggested that "what goes up must come down." As the apple bopped him on the head, he had the epiphany of force gravity, noting the remarkability of opposition. Like gravity, we all have moments of forceful emotional opposition between the good and the bad.

The beauty?

It evokes emotion, allows us to feel, and encourages us to try; sometimes, again and again.

My light khaki, slightly too long, Esprit shorts, red scoop neck Express T-shirt, and tightly gelled, curly ponytail were ready for cheer auditions. Sweat dripped down my neck as I nervously waited my turn in the humid gymnasium with a musky smell. Nobody spoke to me, but I didn't care. I was focused and ready to earn my spot on the squad with the tightest "High

V" and cusped claps my body could muster. As I stretched my splits and prepared my cartwheel, I was ready to go.

Eighth grade had not been an easy year for me. I was ready to leave it behind.

High school seemed thrilling from afar. I was changing school systems and was excited about the promise of new daily routines, people, and opportunities. This would start with the crisp, kelly green color of my cheer uniform with sparkling white Asics that would shine under the Friday night lights of Burley stadium. I'd have a new gaggle of girlfriends, and we'd work the halls in our varsity letter jackets. We'd stuff notes into each other's lockers that would be covered with inspiring quotes, cutouts, and mementos signed with "LYLAS" (love you like a sis).

The manifested vision in my mind filtered out the aerials, back tucks, and back handsprings that were whizzing on all sides of me. My cartwheel would be enough because I was enough, even if I was wearing Keds instead of the much cooler K-Swiss sneakers.

After auditions ended, I sat alone on a bench in the hall, anxiously awaiting the list to be posted. I couldn't wait to see my name alongside all of my new best friends. When the piece of notebook paper was taped to the door, we all rushed and clamored to breathe a sigh of relief about our newfound spot in the social hierarchy of Junior Varsity cheerleading.

When I finally had a clear view of the list, my name wasn't there.

My bottom lip started quivering uncontrollably.

I sulked my way to the car where my aunt was waiting.

I sobbed the entire way to our dinner at the Diamond House Chinese Buffet Restaurant. As I continued crying over my lo mein, she looked at me and said, "Get your tears out tonight and start again tomorrow."

My reckless optimism assumed there was no way I wouldn't make the cheer squad. When I didn't, I was shocked. We all hear the phrase "when one door closes another opens," and I have learned that is true. But the new door doesn't always open in an instant, and the right direction isn't always evident.

Resilience isn't blatantly taught in school; rather, it is something we learn by doing. In order for others to cheer for you, you have to cheer and believe in yourself first. The buildup begins with you.

EXPLORE MORE

One of the first steps is taking the initiative to find and discover opportunities that push you beyond your comfort zone, satisfy your curiosity, and provide directional knowledge about your life.

Towards the end of college, when I decided a career in law was definitively off the table, I wrestled with whether or not I wanted to perform or teach. On a whim, I decided to head to NYC to audition for the non-equity tour of *Dirty Dancing: The Musical*.

Non-equity basically means open to anyone, which was evident as I entered the packed halls of the audition space. Legs were extended in the corners and crevices of windows as dancers warmed up. Walls became makeshift ballet barres. There was no shortage of outward confidence on-site. There was a nervous energy in the air and a cloud of sweat lingered, steaming the windows on a chilly November day. Actors know

how to carry themselves, but that doesn't erase the inner turmoil. Am I good enough? Will I book it? If I book it, what will I do once this job ends? If I don't book it, what's wrong with me?

As I sat there, looking around and reading the room, I knew this wasn't the life for me. I didn't need to throw my leg up in a window or passively socialize. I loved teaching and creating and being behind the scenes. At that moment, I knew that's what I wanted to spend my life doing. So I did.

When there's an inkling that maybe you want to do something, take the step to explore the curiosity. If you love it, great. If you don't, move on. By trying, we learn.

SPEAK UP

There is no one who is going to spread your mission, vision, and passion the way you can and should. We are taught to quietly go about our business in the hopes of others seeing, recognizing, and celebrating our success.

What if we flipped the narrative and went all-in on our self-interest?

Nominations open for something? Put your name in.

Exciting project in the works? Put out a press release.

Want people to support you? Tell them.

Is someone mistreating you? Set boundaries.

Humility has its place, but when you have a gift to share with the world, do not fear using your voice to share and protect it.

In early 2022, I received a direct message on Instagram from one of my former students. They were excited because they saw my first book *Trash the Trophies* on the shelf at a local Barnes &

Noble. This felt very exciting because it was the first I'd heard of my book organically sitting on a shelf. (During the book launch, I might have left a few copies on scattered shelves in varying stores. That would be inorganic, but certainly a great example of shameless self-promotion).

While we knew it was spotted at a Barnes & Noble near our local mall in the Health and Wellness section (between books about the Keto and Ayurveda diets; go figure), my friend Bryan and I decided to go to the Barnes & Noble closer to where we live to investigate. Online, it said they carried the book in stock. Inside, we couldn't find it anywhere, and trust me, we spent a lot of time looking.

I was ready to leave, but if you have a great wing person, they complete the mission. Bryan went right up to the service counter and asked where he could find the book. They shared that it was listed as a local author and that it should be in stock. They ended up realizing they'd never received their copies. I was part excited, part mortified, but all-in for the book exposure and the persistence of my friend.

If others judge you for your desire to be successful, that's on them and their unwillingness to be their best self-advocate.

Put yourself out there and do the work required to make your dreams happen. If I've learned anything, it is that self-advocacy is one of the strongest forms of self-care.

RELISH REJECTION

Whether you are seeking or self-promoting, it isn't always going to go as planned.

I have way more "fails" for every perceived "win." I roll with it because it means I'm trying. I'm putting myself out there, standing in the arena and bracing for what's to come.

I was rejected to be a TEDx speaker a number of times. Then I booked it.

I was rejected for so many pandemic grants. But I received the ones that mattered the most.

I've felt like a strong candidate for many positions and opportunities. Most of the time, I don't receive a rejection letter or response.

In looking at life, I can also say that everything happens for a reason. That doesn't mean it has always felt that way in the moment, but in hindsight, it feels true.

No doesn't mean never. It simply means not right now.

In inventorying your buildup bank, considering the expense of each opportunity, experience, or action is important.

What does the opportunity cost in terms of:

- Energy
- Time
- Growth
- Finances?

What is there to gain:

- If you succeed
- If you fail?

What will you learn about yourself in the process?
Will this change your life?
The breakdown and the buildup offer mirrored opportunities

to push our pain and progress into power. Our experiences deepen our knowledge about ourselves. If we lean into the good, the bad, and the unknown, we will gain a tremendous amount of knowledge regarding our place in the world. Sometimes, both can even happen at the same time.

My freshman year of college was a season of change. I moved from a very small town in East Tennessee to Raleigh, North Carolina. I didn't know anyone. I went from being a big fish in a small pond to feeling like a small fish in a massive ocean. I had a full academic scholarship, and everyone around me was very smart. I felt inferior, and as Eleanor Roosevelt would suggest, it was with my consent.

It was my first time free of everything I'd ever known, and while I was determined to make it work, it was hard. I was grappling with the loss I experienced as a child, and I didn't know how to direct or focus my energies. Pour them into work? Invest them into fun? Figure out how to get the arts back into my life? The possibilities crowded my brain because it didn't feel as though anything was easily falling into place. I thought I could do everything.

Then one day, while sitting in the office of my scholarship director, I learned I couldn't.

In a very matter-of-fact way, the director said to me, "I'm putting you on sabbatical. You have too much potential to allow yourself to implode."

For a Type A overachiever, these words gutted me. Take a semester off? Quit? What would I do? What would I tell people? What would they think? How would I get back on track?

It felt like a huge, end-of-the-Earth blow.

In retrospect, that time was a gift. I slept. I journaled. I took a lot of baths with Glade candles burning in the background. I read books on the balcony overlooking the backyard that was lined with trees. I worked at The Limited in the mall. I watched CourtTV. I was rejected from the first two dance teaching jobs to which I applied. I played with Laila and took a lot of walks. I saw every touring Broadway show that came through the area. I had time to simply be, and it was nice.

In a way, I almost feel like that time gave me a glimpse into what it feels like to discover yourself. There were no standards to meet or burdens to carry. I'm not sure I felt this freedom at the moment. Rumors swirled that I had dropped out. When I had to repeat some of the scholarship program requirements with the class below mine, I was embarrassed.

I was being told not to overachieve and to rest. In that peace, I found conflict because I was concerned about the response of others. How many times do we allow a buildup to turn into a breakdown because of our fears of perception, expectation, and disappointment? It is a prime example of the oppositional forces at work.

When I talk about the sabbatical now, people will often say, "Wow, that was really brave!" It was brave because I pushed and persevered through a pause that I would typically never take. I had someone in my corner who said, "This isn't what is typically done, but this is what you need to do." I've never forgotten that approach, and I try to embody the gentle, yet honest, truth with the people tasked in my care.

In 2018, the feelings from the sabbatical reemerged when I was invited to speak at an industry dance conference in

Scottsdale, Arizona. Hundreds of dance educators and studio owners from all around the world meet up for a series of days to focus on professional development. I had attended this conference twice before, in 2013 and 2015, with studio friends and was excited and a little nervous to return as a speaker.

When the plane landed in Arizona, I started feeling uncomfortable, which was very unusual at this stage in my career. I enjoy speaking and connecting with others, and the nervous energy felt strange. When we pulled into the resort, I had a visceral reaction that was unlike anything I've ever experienced. It had been two years since I had done anything outside of my dance studio in the dance industry, and just like when I had to do the scholarship program activities with a different class, I felt like an imposter. Walking away from competition, something several in this group strongly value, made me feel like an outsider.

I questioned how I'd be able to confidently speak to the group.

Yet in this alternative environment that was far beyond my comfort zone, I did it. And, because I was becoming more seasoned in sitting in the discomfort, I was able to get out there and do my thing. This experience provided the push I needed to manifest my next creative, entrepreneurial endeavors:

- In standing behind that podium, I manifested creating a girls' empowerment program, Girls Geared For Greatness. That fall, it happened.

- In the hall, I met a studio owner who wanted to leave competition, but was fearful of making the move. She felt like she'd lose her entire business. I wanted to follow

up with her and tell her it could be done, but I never got her name. So, I wrote Trash the Trophies in the hopes that one person would be able to find inspiration.

In that weekend of terrible discomfort, I enlightened myself and gained complete and total confidence in my vision and my path. Looking back, it is one of the best things I've ever done.

As we continue our journey to lean into our possibility and power, we have to accept that it starts with our hearts and our truths. In a world that has become oversaturated with motivational mega minds that promise "get rich quick" schemes that are too good to be true, we have a responsibility to ourselves to independently discover, cultivate, and tap into our uniqueness, in our own time.

I used to worry about what others thought in these breakdown and buildup moments.

In dance class, I see it happen when combinations are performed in groups. There's a bit of choreography that's taught, and a segment of the class will perform the combination while the others stand on the sidelines and watch.

When this part of class happens, dancers may shut down, show off, frantically "mark" (or review) their moves in the corner, and everything in between depending on how they're reading the room. It's all unnecessary because no one really cares about any of it. The busybodies gossip because they need something to discuss. Everyone else is too busy worrying about themselves and their next move, in the dance combinations, and in life.

How often do we invent, create, and imagine scenarios that don't exist because of our own personal interpretations and manifestations? Instead of allowing these experiences to restrain

us, we should use it as an opportunity to push ourselves forward by setting loftier goals.

They say that it is healing to laugh in the places you've cried and to stand confidently in the places where you've felt small. There's freedom in owning your narrative, and I'm living proof.

In everything we do, there will be hills, valleys, breakdowns, and buildups. Allow yourself time to soak in the space and use it to fill the possibility of the future. While it's easy to wonder why things happen at different points and places, allow yourself the peace that your journey is uniquely suited for you.

Chapter 6

STAGE MANAGEMENT (THE THREE— RING CIRCUS)

RECENTLY, A FRIEND looked at me and said, "I don't know how you survived the early days of the pandemic without a single glass of wine."

I've never been one who needs to numb or desensitize the frenzy that swirls around me. I sleep well at night, and a lot of that comes from the copious amounts of energy I pour into going full throttle each and every day. My husband calls it a "Chasta Day."

A tremendous amount of organization goes into juggling

my three-ring circus. Each day features many pieces and parts with the layered possibility of the unpredictable. Organization creates tolerance, which opens the gateway for opportunity.

Stage managers are one of the unsung heroes of stagecraft. They keep every department on the same page while the show is in progress: lights, set, actors, props, musicians, sound. If and when something goes awry, they have to seamlessly solve the problem to keep the show moving.

Similarly, we all find ways to manage the show that is our life.

We all have our own version of chaos. Determining how to navigate and manage our circumstances is an individual process, which ebbs and flows depending on the day.

Because my childhood trauma taught me to value time as a most precious resource, I've always loved squeezing in as much as possible. When I read Kristen Chenoweth's autobiography, I treasured the quote, "Drink more coffee, you can sleep when you die."

Part of this zest for life and desire for business stems from the fact that I get to live a life doing what I love. I avoid using the word "work" because I enjoy (almost) everything I do. Enjoyment doesn't erase the craziness, but it makes managing chaos more tolerable. Sometimes, I'd even go as far as to say that it keeps things exciting.

In 2014, I choreographed the musical *Footloose* for Athens Drive High School. The student playing Ren received incredible recognition at our local Triangle Rising Star Awards, which gave him the opportunity to travel to the National High School Musical Theater Awards ("the Jimmy Awards") in NYC. This experience would culminate with the group's performance at the Minskoff Theater, a Broadway stage where *The Lion King*

typically performs. I was so excited for this student—he was hardworking, humble, and ready for anything, including the drop split I insisted on including in Ren's number "I Can't Stand Still."

While checking my calendar, I was disappointed when I realized the Jimmy Awards overlapped with dates I needed to be in Orlando, Florida for a national dance convention. Because of the rare nature and opportunity of the Jimmy Awards, I decided I was going to make it work. I booked a super quick trip to NYC and would fly home to jump in a car and drive immediately to Orlando.

The Jimmy Awards was a fabulous evening. I went to bed late and woke up ridiculously early so that I could get to the airport and catch my flight. As soon as I unlocked my iPhone, I had a plethora of text messages and phone calls regarding a situation at the studio from the previous night. A new student tried an acrobatic class and was overly confident in her abilities, specifically in her abilities to execute a no-handed cartwheel. My leadership team wanted to debrief the situation and recap best practices for moving forward.

I stepped off the plane, jumped into the car, and immediately spent the entire drive on the phone mitigating this situation. It was exhausting, but it was a huge lesson on how you can do everything if you have systems and protocols in place. You can be here and there when you have standardized expectations. At the time, we did not, which is why the eleven-hour drive to Orlando felt brutally long and stressful. It was a lesson in situational management; a necessity for those with a growth-oriented mindset.

Chaos exists, and it will continue to be present in our lives.

We can manage and mitigate it without allowing it to interrupt our peace and our joy if we acknowledge and address the different types.

PLANNED PANDEMONIUM

Planned pandemonium is the craziness we can anticipate. Maybe it's a particularly chaotic week or season. For the dance studios, we recognize we don't really have an "off season," but we know that show season automatically equates to a busier-than-normal time period.

When recital weekend rolls around, it is an all-hands-on-deck effort to guarantee an incredible experience for each and every student. We watch hundreds of students perform in front of thousands of audience members, and it is fun!

With proper organization, planned pandemonium should never feel chaotic. At a recital seminar in my early, studio-owning days, I remember hearing this advice: "Your recital weekend should feel special, like a wedding day or a huge party. You deserve to enjoy it versus dreading it."

I took that to heart, and I believe performance experiences are meant to be celebratory and fun. Part of that fun is the process. Creative people have a level of magical ingenuity that's almost second nature.

When I think about this kind of magic, I smile remembering moments where we made the impossible happen. In community theater, you learn to do exceptional things with $500 to $1000 in costume budgets. If you know showbiz, that's chump change.

When you have a budget line item with that amount, you basically beg, borrow, and pull from closets until you can achieve the look. When I directed *The Wedding Singer*, I remember scouring thrift stores and high school theater departments for pieces from the '80s that would make the show pop.

Jessica is one of my favorite people to work with because her creativity knows no limits. She loves a challenge. When I directed *The Wedding Singer*, she helped me with costumes, props, and basically, anything required to make this show happen. We needed a keytar for one of the principal characters. Buying one would have used the entire prop budget, and we couldn't find one to borrow. So, she bought a block of foam, carved it, and decorated it in glitter. It looked amazing and proves that a flexible mindset can lead to results that exceed anyone's expectations.

Planned pandemonium should never feel like a crisis. It's that hyped up, adrenaline rushing level of energy that can be thrilling if you mentally prepare for it and surround yourself with the right people. These are the moments where we can say, "Bring it on" and make ourselves collectively better in the process.

CHAOS CONTROL

Unnecessary chaos exists, and we can control it from taking over our life. It could be the task that was assigned that was never completed, like the time I almost neglected to order a costume for an entire class series of hundreds of eager-eyed ballerinas.

This type of chaos can be controlled with a strong system of checks and balances:

1. **WRITE IT DOWN.** Put what you need to know in writing. This creates a clear expectation between parties and provides a trail of expectation and communication for future reference.

2. **BE CONCISE.** Keep descriptions and responses short, concise, and clear. Leave out unnecessary information that may lead to confusion.

3. **PROOF AND PROOF AGAIN.** You can never get too many eyes on materials. I've learned the hard way that recital/rectal and shirt/shit are just one letter away from the entirely wrong word.

4. **SET A TIMELINE.** Work within boundaries of time. That way, you can easily transition on to the next project or item without getting paralyzed or stuck in one particular component.

In addition to a strong system of checks and balances, it is also important to leverage the strengths and talents of those surrounding you. Your team, in life and in work, should build you up and make you better. And you should do the same for them.

The STARS method is a little saying I created to focus on the overall development and effectiveness of our team:

1. **SHINE.** Tap into people's strengths and place them into positions where they will succeed.

2. **TRAIN.** Make sure expectations are clearly understood, presented, and detailed.

3. **APPLY.** Observe and make sure skills and standards are being met.

4. **REVIEW.** Give feedback.

5. **SUCCEED.** Celebrate victories and debrief challenges.

While systems and protocols are necessary in creating fair and equitable environments, boundaries are also essential. Boundaries can be difficult, but they provide the ability to make decisions that are free from emotion and rooted in fact. If you remain steadfast in those boundaries, you will reap the rewards.

There have been times in my life where people have pushed boundaries or attempted to manipulate a situation for their own personal gain. By having clearly defined values and an expectation system, the right path for addressing challenges and concerns becomes clear. That doesn't make the process easy, but it makes it evident.

For example, policies aren't personal or directed towards any one person. They're professional and exist to keep the unit moving cohesively towards the collective goal.

When the ego moves to the wayside, it opens the opportunity for operational success.

You can care too much, and you can care about the wrong things, but with detailed, focused intent, you can move forward as swiftly and seamlessly as possible. And you can do it with everyone being organized and on the same page.

THE WILD ONES

Wild, unexpected chaos happens. You can't see it coming, and you have to problem solve as quickly and effectively as you possibly can.

In 2018, I was vacationing in Cancun. The crystal blue waters were dreamy, and we spent most of our days sitting under tiki huts staring at huge iguanas. There's something so refreshing about being away in another place, time zone, or country. Problems don't feel as close.

On a peaceful Saturday morning, the final day of our trip, I was caught off guard when I started receiving messages about a parent casually having a gun in his pocket in the lobby of one of our studio locations. At first, that sentence is highly alarming and concerning, and that's how I felt when I first received the news, especially since I was so far away.

After being caught in an Active Shooter situation at a local mall in 2016 and watching friends suffer the trauma in Sandy Hook, I've always stressed and worried about what might happen if a gun was on the premises. We have an Active Shooter Plan, but we'd never activated it.

Once the full scope of the situation was communicated, I realized there was no imminent danger. The parent had a gun placed in a visible position in his pants pocket. While this is legal in our state, as a child-friendly business, it was unsettling. Several parents were understandably upset, and as a leader, I had to address the situation from a variety of angles.

In my early years of the business, I never imagined I'd be a mediator on such hot topic issues as gun rights and pandemic mitigation strategies. In my position of leadership, I try to lead not only with my head, but also with my heart.

How can we feel collectively and empathetically prioritize safety in order to effectively practice the performing arts? When

we discuss policy and protocol, these minority occurrences help us hone in on the "what ifs?" so we can be more mindful and prepared.

THE BOTTOM LINE

There will never be a shortage of pandemonium to plan, chaos to control, or wild, unimaginable situations that will happen. That's why it is important to make sure the chaos is rooted in reality. How many times have we created chaos that doesn't exist? Or have we pushed ourselves towards imaginative scenarios that are inaccurate?

People are fueled by drama, and anxiety comes from experiences that weigh down our prediction of the future. We can find facts to fit our narrative, even if they are biased or untrue.

In 2013, we were attending the Dance Masters of America National Competition in New Orleans, Louisiana. One of our students entered the national Master Dance of America Competition as an Open Contestant, an opportunity that is provided to male dancers per the organization's rules.

Our regional chapter was offended that I hadn't been fully transparent with our plans and circumnavigated the unwritten etiquette of informing them of our intentions since our student would be competing against the candidate competing on behalf of the chapter. In my opinion, this didn't seem like a necessary piece of information to share. It was legal in the competition playbook, so it was fine.

On the day of the competition, I realized I grossly underestimated the discontent of my peers and colleagues within the organization. The chapter president pulled me aside to inform

me that I had upset a number of people. I explained I was simply trying to provide every option available to my student, and this was a goal he wanted to pursue.

She looked at me and said, "Well, I try to see both sides."

Back then, the phrase irritated me, but nearly a decade later, there's a lot of wisdom in it. "Seeing both sides" can usually alleviate a lot of unnecessary chaos and drama. In fact, I've recently caught myself saying over and over again, "I'm trying to see both sides."

As you're muddling your way through the chaos of the world, take charge of what you can and use these tips to prepare for the unexpected:

1. **BE INFORMED.** We all remember the "Knowledge Is Power" commercials. The more we know, the more we grow. While continuing education is important, chaos is a catalyst for identifying knowledge gaps. Something happens that triggers discord, and we have to learn the ins, outs, and everything in between in order to appropriately respond.

2. **GET ORGANIZED.** Organization is key. If you aren't organized when you're free of chaos, you will drown in the midst of chaos. Have a spot for things, stay tidy, and create systems that work for you in order to keep it all together. As the pace of life increases, having a baseline of organization will be helpful in navigating the unknowns.

3. **STAY FOCUSED.** Chaos is the thief of intention and productivity. Try to be conscious about unexpected chaos derailing your day and productivity.

If there's one thing I've learned, it is that chaos doesn't take appointments. It rears its head at the most inconvenient of times. It's a constant that one must learn to manage and perhaps appreciate. It's a crazy day that becomes a nutty week that becomes an insane month that shifts into an outrageous year.

At the end of 2021, we were all looking forward with optimism to the start of 2022. While the pragmatic part of me recognizes things don't magically change as midnight ushers in a new year, it felt like the timing was right to further move towards functioning alongside the pandemic versus operating in crisis because of the pandemic.

Our first day back at the studios was January 3, 2022, and it was a doozy of a day that launched a doozy of a week. In only a few days' time, I had received so much anger and hostility towards heightening our risk mitigation strategies amid the continued rising cases of the COVID pandemic. I was accused of being paranoid, brainwashed, and using children as pawns for political gain. On the other side, people were once again feeling tentative about the risk level of their child's extracurricular activities and were canceling their membership. Saddened at the state of the world and frustrated with being a business owner in it, I responded that making public health policy had never been my goal. I wanted to focus on dance, and in order to do that, I had a responsibility to keep my students and staff safe.

At some point, we lean in, throw our hands up, spray the dry shampoo, drink the third cup of coffee, and head out to gracefully take on whatever chaos comes our way. If we are showing up and bringing our best with genuine intention for the greater good, we succeed in managing the stage, or circus, that is our lives.

Chapter 7

CHANGING CASTS

WE OFTEN RESIST change instead of welcoming it, but much like pain and chaos, it is a constant. As we move through the world, the world simultaneously moves around us. People, places, moments, and time are fluid. We live in a moment with a hope that the next one will come. We crave opportunities and surroundings that are enriching, uplifting, and rooted in love.

The cast of characters in our life represent the people who surround us. I was once told that you're the sum of the five people with whom you spend the most amount of time, so pick your people and your places wisely.

Confucius adds, "If you are the smartest person in the room, then you are in the wrong room."

I've learned the hard way that this is solid and true advice. When I was younger, I wanted to believe in the good of

everyone. I'm trusting, and I've learned that's not always recip- rocated. In the early years of the studio, I had to release a lot of people for a variety of reasons. Firing isn't fun, and it hasn't gotten any easier with time. The top two reasons are usually misalignment with our brand and an unwillingness to comply with company policy and expectations.

Around 2013, I found an anonymous saying that shook me to my core: Make sure everybody in your boat is rowing and not drilling holes when you're not looking.

Then, in 2014, I saved another, anonymous one: Stop letting people who do so little for you control so much of your mind, feelings, and emotions.

Years later, every time I read these affirmations, I'm equally affected. They're unsettling truth bombs. It strikes deep when you realize that it can be applied both personally and professionally.

The sayings are reminders that guarded caution is not a bad thing. Growing up, my aunt always told me to never be dependent upon any one person for money or happiness. She would confidently say, "You must create that for yourself." Now she says I took the meaning of her message to the extreme. I've carefully leaned into trusting others and delegating more, but I'm not ashamed of the independent approach I've taken in my life. I've watched people around me suffer from naivety and dependency, and a few times, I've found myself almost in that position.

In one business agreement I signed, it said, "If things get to the point where people are quoting contracts, things have gotten very bad." This is a simple sentence that carries a lot of

truth. There's power in noticing how the breakup goes. It says so much about the state of the relationship.

Breakups aren't reserved solely for romantic relationships. They can represent any type of person-to-person dissolution. And much like you can't plan for every horrible situation or occasion that may arise in your life, you also cannot plan or prophesize how long friendships, relationships, partnerships, and acquaintances will last.

People are universally messy and flawed. They bring their own life circumstances, choices, and beliefs to the table. As a guiding principle, it is important to consider if the relationship is rooted in attachment or connection.

Attachment suggests codependency and ulterior motives. It moves away from the humanistic element that we should all strive to infuse into our relationships. On the contrary, relationships rooted in attachment suggest there's something to be gained or controlled, a quid pro quo. Connection suggests human relation, an opportunity to nurture, enlighten, understand, grow, and love.

Whether or not a relationship is rooted in attachment or connection, as casts change and life plays out, there are many moments that leave us wondering: what just happened? What was that person sent here to teach me? Why did it begin? Why did it end?

It's true that betrayal never comes from your enemies. Jesus and Judas and Caesar and Brutus taught us that it can be those closest to you who create the most damage, heartache, and turmoil. In my experience, it usually happens through giving people too much trust, control, or investment. The betrayal is

often secretly executed, while the cleanup reveals the significance of the damage.

Betrayals are like an onion. There are many hurtful and painful layers. I've watched it happen countless times to myself and to others. I am sure there are people who would say I've hurt them. When we make mistakes and create pain, we have to own what went wrong and commit to elevating our interpersonal experiences. Maturity guides us in our wisdom and ability to gain clarity.

I recently rewatched Baz Luhrmann's iteration of *The Great Gatsby*. When I first saw the film, I was enchanted with the visual spectacle. When I rewatched it during the pandemic, my heart ached for Gatsby. The spectacles were an overcompensation for his complete and utter loneliness that was only compounded through the manipulation of Daisy and Tom. Loyalty should not be tied solely to opportunity. And money complicates everything. It certainly does not always equate to happiness.

By the time you've reached the point of betrayal, it is almost always past the point of no return. That's applicable to personal and professional scenarios. Leadership can be lonely at the top, and life can be, too. The times I have felt the most hurt are when the people I'm closest to have turned on me. I've let them into my life and felt the devastating loss of our paths going in different directions. If you've felt that kind of hurt, you know what I'm referencing.

Many years ago, I remember watching a routine on *So You Think You Can Dance?* performed to the DeVotchKa song "How It Ends." The choreography captures the essence of

disappointment, hurt, and loss at the crossroads of a relationship. The pain in the final moment is visceral. It resonates.

Loss in life is very different from loss in death in that there's this hollow vacancy where a friendship, relationship, or partnership once stood. It's weird to know that they're still out there, doing their own thing, and you only share a memory of each other's past. There's an inconclusive void.

In college, I dated someone I cared about very much. We sloppily transitioned into "being adults" while we were together and lived an incredible amount of life in our four years together. The breakup happened on a warm, spring day right after Easter weekend in 2007. I thought a proposal was on the horizon. We had burritos from Moe's Southwest Grill, arrived back at the apartment, and he said, "Hon, we need to talk." Excited, I was confident he was about to pull out a ring. Instead, he told me it was over.

Shocked, I did the only thing that came to my mind. Gallons of milk felt expensive to us at the time, and he was always mentioning the cost. On the best of days, this drove me crazy. On this terribly emotional day, I went to the fridge, broke the seal on the gallon of milk he'd purchased, walked over to the loveseat where he was seated, and poured the entire thing over his head. He proceeded to jump up, raced into my bedroom, and rolled around in my freshly cleaned Kate Spade sheets, saturating them in milk. Then he left.

After that, he was gone. They say there's no use crying over spilt milk, but on that day, I cried over it, literally and figuratively. I got rid of most of the artifacts from that relationship. It was back in the prehistoric era before the internet served as

a chronicle for everything. During a pandemic organization frenzy, I found a birthday card from him from my twenty-first birthday. I read it and felt peace, knowing that nearly fifteen years after the milk mania, there's a reassurance that it was the right thing for the right time, even if it didn't last.

Peace and forgiveness are powerful tools. As we move through life, we have to heal our hearts; otherwise, we become so jaded and fearful that we risk missing something magical along the way.

Even if you aren't gutted and experiencing some significant shift of people in your life, there are also the annoyances brought forth by people on the fringe: the imitators, the imposters, the leechers, and the assumers. None of these people have your best interest at heart. They say and do just enough to drive you crazy without actually being a meaningful part of your sphere.

The imitators are the people who see what you do and attempt to do it. I watch people in other industries lash out at the copycats. It is wasted energy because it interferes with your momentum, your power, and your potential. Inspiration is always more powerful than imitation, and that is where we should prioritize our investment.

The imposters are the people who legitimately have no idea what they are doing and use your expertise to falsify their niche in their industry. Be cautious in how these people represent their relationship and knowledge with you. If they're using your name to leverage their own career, their intentions are in the wrong place.

The leechers are the people who want to own your success and achievement. While there are people who help us reach

success (plenty of them!), in my experience, they are not the people who loudly vocalize their attachment to your achievements. Proceed carefully with anyone who is too quick to align with you and take credit where credit is not due.

The assumers are merely annoyances. They think you're rich, that your life is easy, and that you don't deserve the things you have. These are judgments, and they're an unwarranted distraction. Drown out the noise and get back to doing what you do.

If the people surrounding you keep you at a standstill, or even worse, move you backward, they are not a productive part of your progress. Focus on the people who push you forward and move you ahead. That's where you will find your golden ticket.

Cast changes can be painful, but they can also be one of the most beautiful and magical parts of life. When we aren't expecting it, the love of our life may walk into an audition room, and we don't even know it. You may shake your best friend's hand at a high school dance team interest meeting. The sister you never had may be discovered through private dance lessons.

These moments are the best of living life, and I've learned to cherish the people in my inner circle who are loyal, committed, and transparent. It doesn't mean the relationship will always be conflict-free, but it is worth the work because of the value their steadfastness brings to your life. If we were in politics (and, thank goodness, we aren't), these people would be your cabinet. And you want it to be filled with a small number of people who know you, love you, trust you, and want to move forward alongside you.

There are people in my inner circle who have been in and out at varying points over the years. Usually, the ebb and flow

is related to the process of life, but there have been times it has been because of brutal honesty. Sometimes, the people closest to us tell us things that are hard to hear. Their observations may result in making our lives harder or require us to make a difficult determination or decision.

When I think about the people in my life who have had very challenging conversations with me and still remain in my presence, I remember this powerful quote by Cheryl Strayed: "Our most meaningful relationships are often those that continued beyond the juncture at which they came closest to ending." If we have a handful of "ride or dies" in our corner, we are lucky.

I remember sitting in my office during one particularly stressful day. I was feeling scared about the post-pandemic future of the studio. I looked across the room and said to one of my colleagues, "I feel like the wheels are coming off, and I don't know what to do." Without hesitation, she looked at me and said, "If the wheels come off, we fly. And if we can't fly, we will Fred Flintstone with whatever we've got."

If you remember the Hanna-Barbera cartoon, *The Flintstones*, Fred, Barney, Wilma, and Betty would use their feet to hastily pedal their prehistoric mode of transportation. Their feet would just go and go to keep it all moving.

Find those people who will Fred Flintstone with you.

Stay real, stay loyal, or stay away.

Chapter 8

SCENE CHANGE

IF THE PEOPLE in our lives are the cast, the scene that surrounds us is the environment in which we choose to place ourselves. And in the same way people move through our lives, scenes and environments change, too.

At eighteen years old, I left my hometown near Johnson City, Tennessee and set out to start anew in the much larger city of Raleigh, North Carolina. I was basically bringing the song "Wagon Wheel" to life except I didn't know anyone, and it took me a solid year to figure out which beltline went what way. The first couple of years were hard. I eventually found my footing and Raleigh started feeling like home.

The heart of that home was in the vibrant arts community. Let me be clear: the arts community was not banging down my door from the get-go. It took time, determination, hustling,

and hard work to build my reputation. I probably heard one hundred "Nos" for each "Yes."

As the pace started picking up and I began proving myself, I started living the life I envisioned.

I started teaching dance.

I became an "award-winning" choreographer.

I was running programs of my own.

I opened my own studios.

I started choreographing and directing musicals

There's a moment at the top of act two in the musical *Wicked* where Glinda is getting everything she wants. She proclaims to everyone how happy she is, but deep down, she questions if the checklist of everything we presumably want actually equates to true happiness.

This resonated with me. We can question our dreams, acknowledge that making them happen and keeping them afloat is hard work. Achieving a goal isn't an arrival; it is a stepping stone. There can be celebrations, but the journey is a continual process. Sometimes, it's hard.

We have to learn to appreciate the moments for the opportunities they bring to our lives, even if it's only seasonal. The good only lasts for a certain period of time, and the same can be said for the bad.

I stopped doing dance competitions, but I don't regret the experiences and memories. They allowed me to travel all over the country and see some truly beautiful people, places, and things.

One time, I was judging a dance competition in Memphis, Tennessee. On the flight, I read *The Fault In Our Stars* by John Green. I finished reading it as the plane touched down. Tears

were pouring out of my eyes, and in that reverent moment, I made a commitment to myself to visit Amsterdam. It seemed so enchanting. But, because of my hustle and hard work, It took years to actually get there.

By 2018, dance competitions were fully behind me. I was reinventing myself and had the ability to take a two-week summer vacation (something I hadn't really done since my senior year in high school). John and I visited London, Amsterdam, and Paris. On my birthday, we took the most magical, private, sunset boat tour through the charming canals of Amsterdam. I loved every second of it.

When you look at the photos from the trip, you'd never know that I received some frustrating news. Instead, I look full of life, love, and happiness.

And that's the power of a scene change.

For my film studies minor, I remember specifically discussing *mise-en-scene, which* is the arrangement of scenery and props in a play or a film. When you consider the *mise-en-scene* in life, I find that what we choose to place in our worlds impacts our mood, outlook, health, and well-being.

Think about it. When you consume food, you're deciding how to fuel your body.

When you're working on different stories and narratives, you're regularly ingesting the mood of the material. In 2015, I choreographed a production of *Sweeney Todd*. It was during the dead of winter, and it felt heavy. I'd stay awake at night thinking about the darkness that blanketed this show.

A year later, I worked on *The Wedding Singer* in the spring, and the show was fluffy, fun, glorious, and full of life. There was

a leading cast member who tried to overcomplicate the process through crass scrutinization. That approach was weighing down the group's potential for joy. A couple of weeks prior to opening, it became clear the show could only reach its fullest potential if the cast member was replaced. That's what happened, and it worked.

As a professional, these were all major learning moments. When you're starting out, it is easy to take any opportunity that comes your way with any of the people who come your way. Much like the food we select, we have the power to pick the source material we consume, the environments we work in, and the people who are a part of those processes.

When our disruptive approach jolts someone or something into extreme discomfort, it pushes us more into our power and generates a greater awareness about our personal conviction and brand.

MISALIGNMENT

In 2017, I was working on a show I had dreamed of directing and choreographing, *Ghost: The Musical*. I initially saw the show alone, on Broadway in 2012, and I was excited to bring this challenging show to a small, black box theater that seated ninety-nine people.

I know that sounds impossible in concept, but I had successfully choreographed *RENT* and directed/choreographed *The Wedding Singer* in the same space. Several of our rock star cast members were returning for this production, and I was eager and excited for the challenge. It enabled me to flex my creative muscles, and that was fun.

The process was great…until we reached tech week. Tech week is notoriously arduous, even in the best conditions. You're taking a fully staged and choreographed show and adding in the components of the set, lights, sound, and costumes.

The tech crew was not ready for the challenges required of this production, which heightened the stress of the situation. My desire for excellence was misunderstood as being unnecessarily difficult. In response to the calamity, I sent a letter sharing my concerns, frustrations, and disappointments. My concerns were acknowledged, but they weren't acted upon.

Years after this concluded, I remain unsettled by how my outspoken desire for excellence was confused with emotional outbursts. I don't think anyone meant to mangle this experience, but it was a show that required a lot out of everyone. While there were weaknesses in certain areas, the show did go on, and considering the circumstances, it was a respectable production. I attended nearly every performance. As I reflect on the process, I'm proud of what we accomplished.

When the show ended, I knew returning to the theater wasn't an option. It wasn't easy to leave. A few months after *Ghost* closed, I was slated to direct and choreograph a dream show, *A Chorus Line.* I wanted to do it, and I'd made some tremendous memories and accomplishments in my other shows at the theater. But in setting boundaries and staying true to my positioning, I sacrificed that opportunity, and for the most part have never looked back.

When people, places, and things have standards that are counterintuitive to your own, step away. We cannot force people, organizations, or things to align with our standards and vision.

In time, the right things will come, and it is okay to stumble through the wrong to affirm what's right.

VIRTUAL REALITY

While there's the literal *mise-en-scene* we encounter every single day, there's also the continual landscape shift of the macro picture of the world. It moves around us, and it's our responsibility to keep up. The world shifts. Crises in which we have no control emerge. We worry about what's happening next, even though it is far beyond our realm of immediate impact. There's a balance in maintaining knowledge versus becoming consumed in the stress, chaos, and fear of global situations.

Innovation forces this brisk pace, as we scramble to learn the newest bells and whistles of gadgets. Not only must we learn the newest modes of communication, we must also regulate our consumption of constantly produced digital reality. The digital world is almost as all-encompassing as our actual reality. How do we position ourselves to practice limited engagement in the digital sphere while leaning in to the beauty of actual reality?

Don't misunderstand.

If we appropriately leverage it, technology has blessed us with communication tools and techniques that give us more time and flexibility to pursue our passions. For me, that's performance, traveling, and spending time with those I love. There are times when I'm questioning if I'm practicing my passions enough, or if I'm stuck behind a screen duplicating those experiences in ways that are not as meaningful. I don't have the answer for balance, but it is something I am working to find.

With technology, we've gained an instantaneous platform to share knowledge, beliefs, and opinions. This undoubtedly impacts our perception of reality. There's limited vetting, and we have a due diligence to fact-check what we are consuming as well as what we are producing.

When the immediate or far-reaching world surrounding us feels stressful, it is easy to lean into the horrible. Maybe it's a nasty comment, a hurtful online post, or a triggering headline that evokes anxiety. We don't absorb the celebratory with the same oomph with which we cling to the negative. Recently, I've made a point to intentionally push the good to the forefront of my mind and memory. I save positive feedback and emails because no one has ever suffered from an overabundance of good news.

When you are able to set the scene, let it be aligned with the world you envision. And when you can't control the scene, work as you are able to bring peace, joy, and progress to those around you. Your impact matters, even if it requires trial and error to figure out the scenery that best fits your style. Over time, your preference, wisdom, and outlook may change.

Don't be afraid to let your environment move with you.

Chapter 9

THE AUDIENCE

WHEN IT COMES to the world around you, there are always people watching. People may look up to you, doubt you, and yes, some may even want to see you fail. You have an energetic force field that has a limited amount of bandwidth, and it is important to protect that energy at all costs.

Earlier, I mentioned the importance of boundaries, and I can't think about the topic without mentioning *The Giving Tree* by Shel Silverstein. I was given a copy of this book to read out loud over Zoom during our early pandemic days of digital dance. As the pages turned, I started feeling more and more uncomfortable about the message this book was delivering. Essentially, it encourages people to use you for self-gain until you have nothing left to give.

As we enter year three of the pandemic, I have learned that energy protection and boundaries equate to our greatest source of self-protection. The saying "misery loves company" is not a lie. So instead of putting yourself in a position where misery can commiserate, maybe you shift the conversation to joy? Or maybe you opt out of the conversation completely.

As a person who has had to lead a large group of people during the COVID-19 pandemic, I've grown hyper-aware of the people who are tasked with making decisions in the interest of the collective versus the interest of the individual. This is a tough one, and you can see the weight of it wreaking havoc on institutional organizations at all levels in relation to a variety of topics.

When rules, policies, and protocols are fairly enforced, it can frustrate the boundary pushers who feel entitled to exceptions. In our programs, I am a big believer in flexibility, grace, and understanding whenever possible, but there are still rules, policies, and protocols that must be followed to maintain integrity.

There are times when people have to convene or accounts must be paid. There are operational components that are a necessity to be a functional institution. Setting clear communication and expectations should alleviate any source of conflict. In delivering timely, detailed communication, everyone stays on the same page.

In theory, there should only be harmony.

In actuality, there's always an outlier.

The outlier doesn't understand, receive, or agree to the expectation. They choose to ignore it and act in their personal interest. They are free to make this choice. But choices have consequences.

I have been an outlier. During my senior year of high school, the Park Scholarship Finalist Interviews were scheduled the exact same weekend as guest choreography at my dance studio. I was really looking forward to the guest choreography weekend and was disappointed when I had to turn down the opportunity to dance to be at the interview weekend. In retrospect, my disappointment seems unwarranted, especially since I received the full academic scholarship. But, as a teen, the irritation was real.

I have also had to enforce standards upon outliers. One time, there was a studio event that had one required, nonnegotiable rehearsal with the entire company. Every participant who did not show up was called and reminded of the expectation surrounding the attendance requirement. One participant chose to do something else on the day of the nonnegotiable rehearsal and was unwilling to make an effort to attend for even a partial amount of the rehearsal. When the family was reminded that this would make them ineligible to participate, they were outraged. In fact, they were upset for days and accused me of terrible things, like ruining this child's life and their passion for dance.

Even though I'd set crystal clear expectations, I questioned if I had led this family astray. I consider myself a compassionate person, so evoking this type of response and reaction was never the intent. Was I ruining this child? Had this family genuinely lost nights of sleep over this seemingly avoidable situation?

As I thought about this issue more, it started feeling kind of silly. I wasn't reciprocating the anger this family was showing towards me. I wasn't screaming at them about their choice to attend a different option on the same day of the rehearsal.

Instead, I had:

1. Set forth the standards

2. Outlined the consequences

3. Offered reminders and guidance

4. Upheld my end of the agreement

Bending to this outraged family would have negated the one-hundred-plus participants who knew the time, showed up, and contributed to the collective.

This was a textbook example of setting boundaries, protecting my energy, and playing a consistent and fair game. People watch how you handle these situations. Your response and reaction matters. With boundaries, you invite alignment into your life. The misaligned exit, and the aligned stay.

When I think about interpersonal observations over the years, one of the ones that makes me most uncomfortable is the misplacement of envy for empathy. Both are magnetic, powerful feelings that are rooted in very different places. Yet I've experienced a fair share of both in the studios and in my life.

Empathy is a positive, connection-driven emotion that encourages us to seek understanding.

Envy is a negative, divisive emotion that is rooted in wanting something that isn't yours.

During our dance competition days, I would frequently see envy disguised as empathy. If one dancer ranked higher than another dancer, the lower-ranking dancer and family would passively congratulate the higher-ranking dancer. Within days (sometimes hours), there would be an email in my inbox and

a meeting requested to "discuss" the outcome of the day. This happened so frequently and with such regularity that it became a dreaded, anxiety-evoking pattern in my day-to-day life.

In our new culture, I see empathy organically in play at a much higher frequency. With deregulated, external validation removed, the dancers and their families genuinely care and uplift each other. The accomplishments of the collective are a win for all. The supportive environment is organic, not forced.

These observations aren't isolated to dance.

They're universal.

As you're considering the culture you want to create in your personal and professional spaces, think about the people who are watching. How do you talk about yourself and others? Do you maintain your word? Are you consistent? Are you inclusive?

You don't have to be amazing at everything all at once. I take each day and ask how we can do better the next. Day by day, you'll see change. Then, in one year, five year, ten years, you see the fruits of time evolve into your vision.

People remember how you made them feel through words, actions, and response. There's a song in the musical *Hamilton* entitled "History Has Its Eyes On You." You may not realize how intently people watch or what they'll remember, but they see you in action day in and day out.

In the very beginning of my dance studios, there was a mom, Regina, who challenged me to the very core of my being. She was all-in and knew everything that was happening with everyone. When she walked through the door, an air of spunk followed her. She simultaneously enthralled and intimidated me. The one thing I appreciated was that I always knew where

I stood with her. She was honest and upfront, and while that was slightly terrifying as a new business owner, I quickly learned it was a unique and admirable attribute.

She told me when she was happy and pleased with our programming, and she equally shared when she was angry or disappointed. At the time, I didn't realize the value of this approach. She could be abrasive, but it was out of a place of genuine empathy. Once the family left the studio, I missed her energy and having her family as a part of the community.

When my first book was released, I included her in our launch information. I hadn't heard from her in years and had no idea if she'd read the book or not.

I was surprised to receive a note containing the following excerpts:

> *Thank you for remaining focused and true to yourself. As I read your book, specifically about your insight into competitive dance and your decision to refocus, so many memories instantly came to mind…*
>
> *You gave my kids fun experiences that influence them even today. Most important is for them to learn from your confidence.*
>
> *One of the things I learned from you is your ability not to look back. On several occasions you were faced with tough decisions. You were able to move forward on what was the best for the business and students. You think with your head. I hope my girls will do the same.*

Sometimes I'll read notes with a tear or two in my eye. This

time, I was crying. I couldn't believe that she thought so highly of me. I was moved and had to take some time to gather my thoughts to respond. It was beautiful and reminded me of the power of the community we create and cultivate: past, present, and future.

How often are people watching and listening to us, and we don't even know the power of our impact?

ONE-ON-ONE IMPACT

In 2012, I randomly met a person who quickly became my friend in NYC at the Starbucks near New World Stages. It was a warm June day, and she was considering relocating to North Carolina. Over coffee, we connected in this incredibly deep way that I didn't anticipate. We shared stories of loss and life. Our pathways were shockingly parallel. While she didn't end up moving to North Carolina, it began a beautiful friendship that continues to this day.

Every time we see each other, it feels like no time has passed. When she recently visited, it had probably been six or seven years since we'd last seen each other. A lot of life had happened, and it felt like there was so much to share. As we talked about our children, I shared that I'd suffered a miscarriage in May 2020.

Miscarriage is a topic that people don't readily discuss. I don't know why, but I was initially one of them. Being a part of dance studios, I've been privy to the stories of so many women who experience devastation or loss through fertility struggles and/or miscarriage. Their strength and transparency have always

been inspiring. It took time to become more comfortable with this part of my story. When I did, I decided I would share it with more people.

I found out I was pregnant in March 2020, right at the beginning of the pandemic. It was an exciting time because I didn't always feel destined for motherhood. The news also felt like a beacon of hope in our household during a very isolating period when everyone was heading into lockdown. The future was unknown, but this secret anticipation of life was the burst of joy we needed.

I couldn't schedule my first doctor's appointment until May 6, 2020. In the beginning days of the pandemic, the offices were only seeing people for emergency circumstances. My insurance had updated approved facilities and coverage, so I had to change practices. This was the earliest I could schedule an appointment. Still, I looked forward to that date with eager anticipation.

When I went in for my first visit, I had no idea what to expect. I was nervous, excited, and alone because visitors weren't allowed. Prior to the ultrasound, they allowed me to call John over FaceTime. It was a warm, anticipatory moment...until the doctor paused and softly and solemnly told us that there was no heartbeat.

When she first delivered the news, it took me a minute to comprehend what she was saying. I didn't understand. It was a tragic moment, as this symbol of hope I'd been clinging to had suddenly disappeared. We were both devastated and decided to keep the news to ourselves. We felt like it would be more stressful for others to know in the midst of a time when we couldn't be together.

To avoid potential long-term damage to my body (I was "advanced maternal age"), I had to have an almost immediate D&C. Again, John had to drop me off and pick me up. As I sat alone in the lobby waiting my turn, a lady rolled past me with sadness in her eyes. Dazed, she caught my eye and quietly said, "They'll take care of you." Overwhelmed with my own complex emotions, I avoided eye contact and immediately looked away.

After the procedure, they forgot to call John to pick me up. When I awoke from the anesthesia, he was surprised to hear my voice on the line, but immediately grabbed Elvis and arrived shortly thereafter. The rest of the day was strange. We ate roast beef sandwiches from Arby's and watched the *Cats* movie. We were trying to find some sense of normalcy, but nothing was normal.

This was such a sad, strange, and haunting experience. It happened in a season where so many things were unknown, and my potential for being a mother was now a part of that list. True to myself, I tried to stay positive, but I couldn't help but question why all of this had happened. Because of the chaos of the world, I quickly redirected my attention to saving my businesses, but the grief of the loss lingered.

When I found out I was pregnant again in August of 2020, I couldn't believe it. I was excited, but cautiously optimistic, because we knew what could go wrong. I went all-in on taking care of myself. I wanted this to work, and I was excited to have a family. On May 4, 2021, 363 days after the miscarriage, we gave birth to the sweetest, most perfect child imaginable.

Until I shared this story with my friend, we'd only told a handful of people. Sharing the story that late summer night

felt right. I was in a safe space with someone I hadn't seen in forever, and I was grateful for the time together. The next day, we both returned to our regular lives in different states, and the world continued to turn.

Unprompted, a few months later, I received the following text:

> *I thought of you so many times these past few months and I wanted to thank you so much for sharing the story of your miscarriage so openly with me. I hadn't been through one when you shared, however, I had just found out I was pregnant. Soon thereafter, I became sick and ended up in the hospital alone having a miscarriage. It was a truly horrible experience, but by the grace of God, you had just shared your experience with me and in ways it kept me from feeling isolated in that experience, loss, and pain. Thank you for that.*

I had a one-person audience who heard and received that story in a way that was much larger than I could have imagined. She, too, will soon have a healthy, new baby. In sharing my story, I thought I was merely healing myself when the reality had a much larger impact.

INDUSTRY-WIDE IMPACT

While I used to be painfully private, in small- and large-scale environments, the pandemic gave me the opportunity to share my business failures, successes, and uncertainties with a platform of many studio owners from all around the world. I didn't have the answers, but I was eager to share what was working (and not

working) for us at any given moment. Every week on Thursday at 1:00 p.m. in April and May of 2020, TutuTix, Jackrabbit, and I would come together to share a briefing about the state of what was happening in our world. We called it Coffee & Creativity! One call had over 600 attendees. I couldn't believe it. When the Zoom call ended, I stayed on, reading the chats. I was humbled: Italy, England, Mexico…people from all over were coming together to strategize how to keep dance education alive.

I stayed connected with several people I met on those calls, and we continued the conversation, especially after I released *Trash the Trophies*. I saw people leading their businesses, rising to the occasion, and reconceptualizing their models to best serve their students. From the most challenging of times, we created a bond and identified how we could bring positive change into the world.

UNEXPECTED IMPACT

We can also inspire people at the funniest or most unexpected of times.

In 2019, we were rehearsing for our annual dance recital in a professional venue. Union stagehands are required, so I always hire a stage manager to serve as a facilitator between the venue and my team. During rehearsals, I sit on stage left and run the rehearsal over a microphone, a "God mic" as you call it in theater terms.

One of the tech crew in the booth kept telling our stage manager that my voice sounded like an ethereal fairy. The stage

manager, a personal friend, thought this was hysterical. On the last day of tech rehearsal, the crew member, a person I had never met, came in with a three-foot metal fairy sculpted to "match" my voice. He signed it and presented it to me on stage left as a work of art to represent the beauty and inspiration of my literal voice.

This was a grand gesture, and it came out of nowhere. It was so random, but it tickled us to no end. We laughed so hard then and still giggle about it to this day. As I buckled the statue into the front seat of my car and headed home from the tech rehearsal, I wondered, "What in the world just happened?"

DELAYED IMPACT

Sometimes, we don't even realize the level of our impact until many years after its occurrence.

Several years ago, I taught a student from preschool through her elementary years. She left dance to focus on gymnastics, but she was very bright and had a promising future. Out of nowhere, I received the kindest message:

> *I miss you. I remember in dance classes how much I looked forward to dancing every week. I still have almost all of my SDD recital costumes in my closet and they bring all of the memories anytime I see them.*

These memories build our future and give promise to a brighter tomorrow. We invest today with the hope that our actions will contribute to a better world and place, not only for the students we educate, but for our own children and loved ones.

When life allows us to create community, on a small scale, large scale, or even in just a randomly weird moment, we should embrace it. By building connections in good times, we have a support system in place for the more challenging times.

This helps us create an inspiring, joyful life that we want our youth to emulate and watch. It includes our actions, how we use our voice, the way we treat others, and our digital representation.

Every piece of it matters.

Because even when we aren't on stage, there are still audiences watching and clinging to our stories in our everyday life. When we are aware of our impact, we open the gateway to our fullest potential.

Chapter 10

THE REVIEWS

> *"It is not the critic who counts; not the man who*
> *points out how the strong man stumbles, or where*
> *the doer of deeds could have done them better.*
> *The credit belongs to the man who is actually*
> *in the arena..."*

—THEODORE ROOSEVELT

THIS IS A long quote, and if you don't know the rest of it, I encourage you to look it up. My husband gave this quote to me long before I ever fathomed he might be my husband. It was during a challenging rehearsal period for a show we were working on. He saw I was working at my maximum potential, and I was facing some resistance in the process. He told me to

watch the movie *Whiplash* and embrace this ferocious level of conviction I carry in my soul.

I laid awake one night watching the movie on my iPhone under the sheets of my bed. I stayed up way too late and thought about this quote for way too long. I wrote it out on a pair of drumsticks with a Sharpie and gifted them to him as a token of gratitude for his support. The drumsticks sit on a shelf in our house, reminding us that critiques and reviews will happen. It's a by-product of the audience we mentioned in the last chapter, and it happens because we have courage to put ourselves out there.

If people are judging and critiquing you, really amazing or extremely horrible things are likely happening in your life. You are giving people something to talk about, and that, in itself, is commendable.

I'm a relatively calm person (or I'm calm until I'm not). I don't enjoy conflict, and I rarely raise my voice. I find that being exceptionally angry requires a taxing amount of energy that I'd rather repurpose in more productive ways. When the reviews roll in for the things I do, I try to process them with a clear head before reacting or responding.

I ask myself the following questions:

1. Is this worth my time and energy?

2. Is there anything I did to make this person feel this way?

3. Could the person have something going on in their life to make them feel this way that has nothing to do with me?

4. Am I overreacting to this response because of things that are happening in my life?

The examples I could list of criticisms are quite possibly endless. They arrive from everyone: people we know, perfect strangers. They happen in different formats: through the grapevine, online, and, less frequently, face to face.

THE COWARDLY REVIEW

In the second year of the studio, we had a routine called "Doctor, Doctor." It featured all genders in a variety of medical-themed costumes. The male dancers wore white lab coats and black pants. Some of the female dancers wore a full, rose-colored scrub set, while some had a Mickey-and-Minnie-themed scrub set with white pants. The colors cohesively pulled together to look sharp on stage. It was a tap number—the intention was for it to be fun and entertaining.

A few weeks after the recital weekend, I received a typed, anonymous note in the mail. It complained about Recital DVD prices being too high, and then went into a tangent about my sexist presentation of the dancers. The writer assumed the females were presented as nurses only (inaccurate), whereas the men were presented as doctors (also, inaccurate). This was a gross generalization that was upsetting. I would never say that gender identity limits success or accomplishment in any career field. Any gender can be a nurse. Any gender can be a doctor. And, furthermore, we should celebrate both equally.

Since the letter was anonymous, I couldn't respond. It seemed like a cowardly, hurtful way to present a criticism. There was

no way to offer a conversation, resolution, or gauge the intent behind their perception.

THE UNWARRANTED REVIEW

I also quickly learned about the ease with which perfect strangers can eagerly and readily criticize your work on the internet. In 2014, I was slated to choreograph a regional musical comedy production (unique to our area) of *A Christmas Carol*. The year 2014 was the fortieth anniversary of this particular production, and it would play to thousands of people in two different venues. I was excited for the opportunity and looked forward to diving into the challenge.

Early in the rehearsal process, a video of a dance rehearsal made its way to social media. It was innocently posted by someone from the production team because the cast was working hard. They were looking good! I believe the rehearsal environment is for work versus a finished product, so I didn't mind this behind-the-scenes peek.

Later that evening, my phone went abuzz about a status that had been posted on social media from one of the show's former choreographers. It was very angry and criticized the work that was happening, specifically in regards to my choreography.

My choreography was described as:

- "Amateur"

- "Lackluster"

- "Flat out boring"

I didn't understand this person's desire to attack my work.

Now I know that this response was a reflection on their experience, perspective, and feelings. One thing I've learned is that people will feel all kinds of things about you, and most of their feelings will have nothing to do with you. When it happens, you have to prioritize maintaining your integrity.

After this happened, representatives from the show gave me a card, flowers, and a boost of goodwill. I went back to the rehearsal room and continued to rock it. I choreographed the show for four years before I decided it was time to move on and open the opportunity to someone else. I loved the experience and did not allow the stranger's fiery words to rob me of my joy. We created solid work, and most importantly, I feel like we all grew together in that experience.

REVIEWS TO RISE ABOVE

Condescending growth is never productive.

When the catty emerges through critiques, it can be hard to pause the thoughts of what could have been better. Our self-doubt and insecurities creep in. Negativity bias is a real thing that pushes our focus to linger on the bad. We replay, overanalyze, and stress ourselves out for no real reason. When we mindfully lean into the positive, it creates a happier, more intentional approach to our life and actions.

With that being said, we must monitor our reviews with the equal force in which we monitor being reviewed. When I find myself judging more than enjoying, it can almost assuredly be tied back to an insecurity or negative feeling/experience. Social media invites us to seek comparisons and judgment on

a constant basis. It's not healthy and continues to remind us that we must dutifully monitor the media that we consume.

In that same vein, there are people who want to drag down those who are attempting to better the world around them. There's a song in the musical *Wicked* called "No Good Deed." This number questions whether altruism is pure in its motivation or if it's driven by the need for attention.

This question is relevant.

Do we do acts of kindness for good, or do we do it for recognition? Is our altruism organically motivated, or do we do it because we think that's what we are supposed to do for college applications, professional notoriety, or acceptance within our peer group?

There's a buzzword for this, and it is called "virtue signaling." When we landed on the tagline "Be More At Stage Door" for the dance studios, a former member of our community publicly questioned our intent to use this tagline on merchandise and in our branding.

I genuinely thought about this person's negative perception.

Was I just seeking attention?

Or were these words an important part of my vision and direction that I would fully commit to upholding?

My intentions were pure, and I decided I would not fall into the trap of this superfluous judgment. Instead, I'd lean in to the tagline, commit to it fully on a personal and professional level, and we'd all rise because of it. That's what happened. The power of that tagline was exceptionally evident during the COVID pandemic. Now that the tagline has existed for several solid years, I'm seeing confident, adaptable, resilient

dancers and humans who inspire themselves to "Be More" in everything they do. That's not a virtue signal, that's real work.

The words you speak must match the actions you live.

REVIEWS TO IMPROVE

Speaking of real work, there are times when critiques have been warranted. I'm a big believer in using knowledge to improve, and the heart of that starts with considering the human experience. I regularly ask, "Are we treating the people in our care the best we possibly can with the resources that are available?" If the answer is anything but a resounding "YES," we have work to do.

One example that easily comes to mind is inclusivity in regard to dance apparel. Many years ago, we used tan tights for a Hip-Hoppin' Peeps Class. As we became more educated in our approach to inclusivity and diversity, we realized the tan tights were not an appropriate choice for a diverse population. We completely eliminated the tan tights from our rotation. We also started using the language "skin tone" instead of "nude" for undergarments. As our attention towards truly creating an open, welcoming environment for all heightened, we became aware that we were unintentionally making choices that were not in the interest of inclusivity of all.

As soon as we knew better, we aimed to do better.

Listen.

Learn.

Improve.

In the summer of 2021, we had another learning opportunity. We offered a Recitalpalooza instead of a traditional end-of-year

HANDLE THE HORRIBLE

recital. We were still dealing with COVID limitations, so moving it to an outdoor festival-style setup seemed like an exciting alternative that would preserve the magic of the recital season. Since the venue still had a capacity limit for the audience, we decided to use our favorite videography company to professionally video and livestream the entire affair.

This was a good intention, but we made a mistake. We had a handful of students on a "no media policy" list. Since the livestream was being broadcast on YouTube, we didn't record their classes to protect their "no media" requests.

In making this decision, we missed out on having all of the students in those classes on film. After discussing it with the families, including the "no media" families, we came up with an alternative solution to reshoot those particular classes.

We knew we had to do better, so we immediately set into place new policies for the following season to prevent this oversight from recurring. Respectful, collaborative dialogue made this happen, and every impacted family returned.

THE POWER OF BEING SELF-AWARE

For anyone who puts the hours, time, and conviction behind creating a cause, do not allow the challengers to tear down your vision. Stay tall, remain focused, and get it done. If you ever doubt yourself or feel distracted in your purpose, remember the reason why you started, and your path will clear. When mistakes happen, own them, and then make them right.

Take the frustration you feel and push that energy towards momentum. The paradigm shift will help you sharpen your

vision and eliminate distractions. Do not let the external sway your ability to do what you were put on this earth to do.

It's easier said than done, I know. But, your time, energy, and talents/gifts are limited resources. Protect them at all costs.

I've found that my most emotional responses are tied to times of heightened sensitivity. This may very well be true for the people with which you engage and communicate. We have to make sure we aren't creating horrible, imaginative places where horrible doesn't actually exist.

I saw this meme one day, and I saved it to remind me that people will say mean things, the public may judge your choices, and your actions may not make sense to everyone.

Mirror, mirror on the wall, I'll always get up after I fall.

And whether I run, walk, or crawl,

I'll set my goals and achieve them all.

As long as you're pushing towards the greater good and staying true to you, that's what matters most. Please yourself first. Please the audience second.

Chapter 11

SCRIPTS

SCRIPTS HELP US perform shows and create detailed systems, strategies, and protocols. The text guides the idea to life. Similarly, scripts can also allow us to crack crises.

In bingo, when you fill out a card, it's called a Blackout. The summer after my mother passed, I spent several weeks with my aunt and uncle at Pope Air Force Base as they prepared for their move to Tennessee. We'd often play bingo at the community center, and with my stamper in hand, I'd be ready to mark any and all spots on my card as they were called out.

Now, if a bingo card was filled with horrible and inconvenient scenarios, I would bet that I could call "Blackout!" faster than anyone in the room.

That doesn't stop me from pushing forward. We live in a world that warns against "toxic positivity," the idea that we must maintain

a positive mindset regardless of the dire or extreme nature of the circumstances. However, we can grow through what we go through, and we can use it to motivate a better version of ourselves. We can use it to tweak, edit, and refine the script of our life.

I hate snakes. Like, I really hate snakes. My skin crawls when I think about them. One day, I had a young dancer share her excitement over a seventeen-year-old female entrepreneur's company that delivers educational programming about reptiles called…wait for it…Snake Experience.

I was initially a little guarded, but in offering a full representation of pathways, it made sense to invite this company to be a presenter for one of our Girls Geared For Greatness programs. Girls Geared For Greatness is the nonprofit I founded in 2018. The organization focuses on leadership development for girls ages seven to eighteen to support them in their intrinsically motivated journey towards greatness. We talk about leadership, executive functioning, entrepreneurship, perseverance, and ways to impact our lives and the community.

Snake Experience responded almost instantly, and we set the program into motion. A few months later, I was watching tubs of snakes and reptiles enter the dance studio. As they entered one by one, Sara yelled, "Chasta, this is a lot of snakes!" It's a phrase I never expected to hear within the walls of our building. It was surreal, but exciting, because I felt like I was personally growing in this moment. Ten years ago, I never would have done this, not in a million years.

As the program progressed, I decided I would take it to the next level and hold a snake. It was a large boa constrictor named Diana, and she weighed over twenty pounds. I didn't quite have

the courage to hold Diana on my own, but my enthusiastic buddy from earlier in the book was there and was willing to do a team lift. I took the non-head part of the snake while she held the other end, but the snake's head kept coming towards me as she repeatedly flicked her tongue. I must have only held her for seconds, but as the snake's body wrapped and squeezed around my wrists, a few seconds was more than enough.

One of my staff members, Brooke, documented the entire, short-lived experience, and the series of photos perfectly captures the way we must think of crisis:

1. **THE RESISTANCE:** That clenched-up feeling of saying "NO!" this isn't going to happen

2. **THE ACCEPTANCE:** While inconvenient, the realization that this is happening

3. **THE PUSHBACK:** The bring-it-on attitude of making it through the experience

Our collective experiences impact our existence.
We face the snakes, literally and figuratively.
Inconveniences.
Hardships.
Difficulties.
Disruptions.
Challenge.
Loss.

That's a weighted list. Some of those experiences may even reach the point of crisis, which could lead to trauma. Crisis being the event and trauma being the response.

If there are doomsday preppers in the world who prepare for their worst-case scenario, my "doomsday prepping" focuses on how to overcome whatever happens on any given day. We can't sit around and wait for the bad to happen, but we can be mentally prepared for our response.

When horrible happens, it may feel like life takes a step back. I have an incredible disdain for anything that feels regressive. I don't want to stand still; I want to move forward. But we can't control everything, and sometimes, we must sit in the pause. There are things you can't wish away that you must problem solve and address.

Once they're handled, you heal.

As you heal, you gain power.

As a part of that power, peace will arrive at your door in the form of choices.

During times of challenge and conflict, here are ten tips that help me make productive choices:

Avoid Comparative Language

I've learned that saying things, such as "This can't get any worse" or "This is the best day ever," are counterproductive to clarity. When we use comparative language, we set an expectation. When life happens and that expectation is disproved, it can feel even more frustrating than the initial experience.

Reframe Negative Thoughts

We are constantly taught to consider how we speak to others, but we also have to be mindful of how we speak to ourselves.

Being honest with our feelings is important. A slight shift in framing can go a long way in our outlook.

My life is terrible. This day is challenging me.

I can't believe that happened. What is there to learn from this opportunity?

I failed. I will be stronger because of this.

Pass the Torch

Use your voice to share and spread the good and watch it come back to you.

My first dance instructor, Joyce Daniels, made an incredible impact on my life. I think of her often, and I am especially drawn to how she infused the classics into the artistic conversation of a rural area in Eastern Tennessee. I grew up obsessed with "How Could I Believe You When You Said You Loved Me" from *Royal Wedding* with Jane Powell and Fred Astaire and the title number from the toe-tapping Cole Porter musical *Anything Goes*.

I've always remembered this exposure, and I try to pass it on and instill it in my students. In September 2021, I was shocked when I heard from Joyce.

She remembered me.

I took the moment to thank her profusely for the knowledge she instilled in me from a very early age, and she wrote back one of the most powerful responses I've ever received: "*You were one of the few who understood what I was trying to accomplish with the students.*"

Absorb what motivated and moved you at varying points in your life and pass it on to others.

Find Your Mantra

I'm a fan of anything themed or kitschy. In the early pandemic, I needed mantras to keep my mood focused. I knew this was going to be a marathon instead of a sprint. I had to stay focused, so I put these reminders on nearly everything.

- **GRATITUDE OVER GRUMP.** When grumpy feelings set in, counteract them with gratitude. Think of something you are thankful for; it's an immediate mood shifter.

- **OPPORTUNITY OVER OBSTACLE.** When hard things happen, I'm also looking for the gain. There is opportunity in everything.

- **FAITH OVER FEAR.** Fear paralyzes. Faith is an important tool to combat it.

Don't Let It Consume You

Elsa said it best when she said to "let it go," and the neuroscientist Jill Bolte Taylor, PhD agrees. Taylor recognizes that when you feel an emotion created by a negative event, it takes only ninety seconds for the body to produce the resulting stress hormones and return to its baseline setting.[2]

When we find ourselves dwelling or obsessing over something, we need to have the self-awareness and self-control to redirect our energy.

Others sense and feed off the vibes we emit. If we want

2 Martha Beck, "Martha Beck's 5 Rules for Lasting Joy," *Miss Moran (blog),* July 16, 2014," https://www.missmoran.com/2014/07/martha-becks-only-reason-that-i-still.html

HANDLE THE HORRIBLE

to curtail negative energy, we have to be mindful of what we project. Anxiety and nervousness are contagious.

Stay True to You

Your authenticity is your greatest treasure. Instead of resisting it, embrace it.

When society suggests you should change, stand strong in your truth.

I'm weird. Really weird. I love cleaning my dog's ears, eating hummus and American cheese sandwiches, and picking dirt out of the grooves in my Birkenstocks to keep them super clean.

You won't find that information in any of my professional bios, but it makes me who I am.

We all have our quirks, and we should never hide them simply because they don't fit the narrative of someone else.

Practice Good Habits

Routines and habits stabilize our lives and impact our success, for better or for worse.

When my routines are in order, I thrive. While you may hear me say, "I'm getting organized" on any given day, I'm probably in the top percentile of organized people you may know.

In addition to having a plan, there are three other things I must do to have good zen. Mind you, I've only started doing these three things daily over the last three to four years. I have outwardly failed at them in the past. That shows that things you want to do can still become a habit. You've simply got to set it into motion.

- **HYDRATE**—One hundred ounces of water a day, always (and yes! I used to hate drinking water.)

- **MAKE THE BED**—It may not be perfectly made, but once it is made, life feels more in order.

- **MOVE MY BODY**—Physical activity is a gift. I find a way to move every single day. Some days, it may be a super short window of time, but it still increases my mental focus and clarity for the day.

Rediscover the Familiar

What makes you remember why you started? What keeps you going? Family (blood or chosen), the familiar, and the concept of home are all important things to cling to during difficult times.

No matter how busy we get, we must always take time for the people, places, and things that have taken the time to invest in our spirit, soul, and success.

I find comfort through:

- A nostalgic meal (macaroni and cheese mixed up with peas is my go-to)

- A familiar TV show or movie

- Blankets

- Cuddles

- Quiet days (holidays, snow days, times when the world is quiet)

- Being around my family or longtime friends

Travel

Nothing will light your soul on fire like a scene change. Get around other people and places. Immerse yourself in how they choose to live and experience life.

When you find yourself in a rut, I believe in escaping your normal. It awakens the senses and generates the possibility of excitement.

Travel bridges the intense professional commitments I carry. Setting travel benchmarks forces me to schedule breaks or shifts in my demanding routine.

When we had a baby, people made it sound like travel would be impossible. Instead, I find it even more fun and exciting to see the world with our full family in tow (and yes, that usually includes Elvis, too).

Get Inspired

When your well runs dry, you have to know how to seek inspiration. It doesn't always require grand acts or gestures. Often, it can be reading a new book or reaching out and engaging in a conversation with someone you admire.

Some days, inspiration may be that whisper that tells you to "keep going" in spite of the hardship you're experiencing.

Other days, it will ring a bit louder. Someone may say you've changed their life, or you'll achieve a goal you didn't think was possible.

When you're steady in your routine and not experiencing the grim or the great, look for inspiration. Read books, buy magazines, watch films, do stuff, and listen to the stories of others.

Input equals output, and the more we consume that can potentially impact and inspire us, the better.

These simple, everyday tips have helped me manage, cope, and thrive in my day-to-day existence. While nobody wants to invite crisis or conflict into their lives, it's there. We may not be able to control what happens to us, but we can control our response and readiness. If we track the habits that work well for us, we develop our very own script for cracking the crisis code.

Chapter 12

CURTAIN CALL

"We shake with joy, we shake with grief. What a time they have, these two housed as they are in the same body."

—MARY OLIVER

IN THEATER, THE curtain call marks the end of a show. Everyone parades in celebration of the performance they've accomplished. They bow, the curtain closes, the cast celebrates, and the audience goes home. If it's a really good show, curtain calls always feel a little bittersweet. It's a procedural ritual that represents closure.

(And that ritual is highly regarded. One time, I was directing a show and opted to eliminate the curtain call. After the show,

an outraged audience member berated me, in the lobby, about this directorial decision, claiming that it had robbed her of her chance to thank the performers.)

For the longest time in high school and college, I carried a fuchsia, three-ring binder that had a clear cover. I printed the poem "Elm" by Sylvia Plath on a pastel pink sheet of paper in a nice cursive font and slid it in the front. It's a somber poem that I liked having close to remind me of the varying beginnings and endings in life.

It is argued that the poem is ultimately about lost love and rebirth, personified through the metaphor of the tree. I've always been hyper-aware of the temporal nature of each part of life. Everything has a reason and a season. The challenge is living and loving those moments to their fullest, so that we can celebrate their passing and eagerly await what happens next.

One weeknight in elementary school, I was staying at my grandmother's house. We always watched *Jeopardy!* and *Wheel of Fortune* and made caramel popcorn in the microwave as a treat. On one particular evening, as we were waiting for the microwave to ding to indicate our caramel was fully melted, she said, "Watch the microwave timer countdown. Those are the seconds of our life passing us by."

The seconds pass faster than we realize. In March of 2001, I watched my grandfather exit this earth quickly from lung cancer. It felt as though he was here one day and gone the next. While I don't remember the death of my father, I vividly remember the death of my mother and experiencing another loss of an immediate family member was tragic.

A few months after my grandfather's death, my uncle, my

mother's brother, welcomed his first daughter into the world. The significance of the circle of life was not lost in this moment, emphasizing the fact that we are all coming and going in this journey of life.

Since then, I cling to moments without acknowledging the sadness transitions may evoke. Joy must be celebrated where and while it exists. Like a play or performance, this life we live is fleeting.

Birthdays bring peace. Each one is a gift and a moment to celebrate.

Friends moving, literally or through life phases, can be tough. I practice celebrating the success this represents for them instead of focusing on the disappointment of missing them or the way things used to be.

Show closings are bittersweet. But shouldn't we smile since the next opportunity may be even better?

Trust the wait. Lean into the uncertainty. Because when nothing is certain, anything is possible.

Around 2015, I was in the midst of some major professional changes. Inwardly, I was also recognizing dissatisfaction in my personal life. I started working towards this idea of a personal renaissance that would lead me to a truer, more purposeful place in life. It took a lot of tenacity and resilience to stay true to this calling. It would have been much easier to stay planted in the life I had normalized. After an abnormal childhood, I really wanted this feeling of normal, but I couldn't shake the feeling there was something more.

During this time, I stumbled upon a post in *The Gloss* that shouted itself off the pages and into my heart:

Following your dreams isn't always about seeing them all the way through to their happy ending. Sometimes the end comes sooner than you thought it would. Sometimes the end of a dream isn't the Oscar or the Nobel or the giant corner office; sometimes the end of a dream is simply the quiet moment when you admit to yourself, I'm done now. That's not failure…that's freedom. It's the freedom to do other things and follow new paths, whatever and wherever they may be.

For me, it was the dissolution of my participation in competitive dance which was a prelude to the dissolution of my first marriage. When you start things, you never anticipate that they'll fail. You don't anticipate that you will do something successfully and intentionally end it, or that you will invite a person into your life and never see them again. As both of these major pieces of my life dwindled to nothing, I was left in the reflective quiet.

It was there that I eventually found a heightened sense of personal power.

When I look at before-and-after photos of this period of time, I barely recognize myself. I feel like the before photos are very flat. In 2016, I recorded a video about reinvention, which, at the time of publication, can still be viewed on YouTube. There's a saying that claims change is hard at first, messy in the middle, and beautiful at the end. When I recorded this video, I was right in the middle of the mess. Once I finally made it through this strange, transitional period, the after photos are so effervescent. In the moment, we can't always see the things we inwardly know.

This period of time was laced with a lot of judgment, anger, and anxiety. It wasn't fun, but somehow, in the midst of these horrible and painful experiences, I found the most authentic version of myself.

One day, a friend I hadn't spoken to in a while called. There was a lot to catch up on, particularly in regard to these big changes that I had been privately holding and only sharing on a need-to-know basis.

Our conversation went something like this:

Me: *I left the competitive dance industry.*

Them: *It's about time.*

Me: *I'm getting a divorce.*

Them: *Congratulations. Snakes shed their skins and sometimes humans do, too.*

The stability I created in this engineered reality was likely a facade for the instability I faced in my childhood. Run a successful studio and participate in dance competitions like everyone else. Check. Get married and live a settled-down life. Check. When those two things dissolved, I was reminded that life can make a seismic shift at any moment. When the world rocks, we have to be ready to roll, and I was ready to fully accept any tidings of good joy the universe had to offer.

One night on a whim, while sitting in my new, fairly empty condo as a divorcee, I decided to apply to be the Executive Director of the Los Angeles County Arts Commission. Maybe a scene change would be exciting and refreshing.

My cover letter started with:

> "Do you remember your artistic firsts? The first time you
> saw a community theater production? The first time you

entered a piece into the public school's art fair? Your first dance recital?"

It ended with:

"In short, the arts changed my life. The arts change lives every single day."

I didn't get the job. I didn't even get an interview. The process of thinking about the possibility of leaving once again awakened my soul to the realization that everything I ultimately needed was right here, in front of me. I could create it. I could lead it.

In taking control of my professional life, I was equally determined to embrace my personal life by feeling more, loving deeply, making memories, and cultivating experiences. This chapter ending gave way to an entirely new opportunity. Failure, in whatever form it takes, is often a launchpad to discovery, success, and true reinvention. Our lowest point generally leads to our greatest success, even if it takes more time, energy, lessons, and heartache than we'd prefer to endure.

While we can aim to march forward with energy and pep, it would be remiss to neglect the greatest curtain call of all: death. Simply put, this experience cannot (and should not) be rationalized or overcome. When I think about the precious people and pets that have left my life, I feel it in my throat, a tightening in my chest. The memory is so strong and visceral that it feels almost overwhelming. That powerful sense is a testament to the beauty they plant in our lives. They live in us, and they always will. When we think of loss and losing loved ones, when we fear it, it is because we loved so purely and deeply.

That doesn't make the process any easier. There is no formula

to grief. Loss is loss. Whether we experience it as someone taken too soon or someone at the end of a well-lived life, it doesn't ease their transition or absence.

I've grown to live with my grief.

I use it to fuel my impact, and only recently, I've started being more transparent and candid about my journey. In sharing my story, I've discovered this greater connection in the universal experience of grief. Yet, collectively, there seems to be a road-block to being comfortable in sharing our feelings.

As my heart opened and my story was shared, I became closer to the losses that impacted me as well as my inner voice. By saying their name, looking at their photos, acting in their interests, and remembering the celebratory times, we keep their memory alive.

Growing up, we'd travel from Tennessee to Myrtle Beach most summers. I loved this time with my family because it meant delicious dinners at the Japanese steakhouse with a true treat—Shirley Temples. I remember one specific occasion when my mom planned a special outing to Chuck E. Cheese. I had on a tie-dyed purple romper, and she had recently purchased a huge, shoulder-sitting camcorder and was eager to record everything we were doing. From behind the camera, she questioned me about my excitement for that evening, and sheepishly, I played along.

I love that video.

I don't visit Myrtle Beach frequently these days, but I did go there in August 2021 with my husband, dog, and three-month-old son. As I sat on our balcony, in awe of this full-circle moment where I felt flooded with memories, I sensed a calm

presence that engulfed me with the breeze of the ocean. With tears streaming down my cheeks, I felt a powerful force embrace me. I have no doubt this was a sign from my mom. She used to drop notes in my lunchbox, and on this day, she was dropping by to remind me that this is my path and everything is going to be okay.

Moments pass and grief hurts. The beauty of this life is to live it to the fullest with each opportunity we are gifted. Take the time to make memories. Cherish the conversations. And as chapters close and people go, cling to the good and allow it to be part of building you up.

Chapter 13

ENCORE

IF WE ARE open to receiving the lessons of our experiences, we can create richer versions of ourselves. As we become more confident and capable of our power, we may decide something doesn't work. We get to direct the lives we live, even if we can't control what happens to us.

We have to own that we are the star of our own show. As performers, we tend to want to prioritize everyone and everything else first: our performance, the cast, the crew, the audience, the reviews. We aim to please, sometimes at our personal expense. The mentality becomes "don't worry about me, I'll worry about you."

When we know it and acknowledge it, we can work on it.

I recently practiced this when I resigned from every board of directors I served on. At this place in my life, after multiple

years of crisis leadership, I need to focus on what's happening in my immediate world. I need to be a free agent who is untied to the regular commitments of other organizations. One day, I may return to these types of positions, but it is okay that the time isn't now. The guilt is gone.

As I work on taking better care of myself, I've also become attuned to the false narratives of others. Prior to having my child, someone mentioned that my husband and I would "never eat together again." That seemed a little ridiculous. I shared my thoughts at a therapy session.

My therapist offered these incredible words of wisdom: "We cannot compare our scripts to the scripts of others, and often, people will try to push their negative experiences and scripts onto your life. You don't have to accept them. Their journey is not your journey."

Finding yourself, calming yourself, and learning to live a joyful, present life is work. It is work that never ends. By frequently practicing self-awareness, you gain power over your emotions. When hardship hits, you have to decide if you're going to rise or fall. The mind is a powerful tool that we must leverage to our benefit.

Past pain should not prevent future gain.

We have to take on the role of a shareholder in our life. Think about it from the outside. What are the stakes? Where are the risks? What are the gains?

During the 2021 holiday season, I kept thinking of the lyric from "O Holy Night," *the weary world rejoices.* As we welcomed 2022, the world became weirder as the chaos continued to heighten. Because of the new COVID-19 variant, named

Omicron, people reverted to the panicked response of the early pandemic days of 2020. Again, this virus wreaked havoc on all of our plans. We had to divide our planned January studio NYC trip between remote participation in North Carolina and live participation in NYC. We dealt with staffing shortages, student absences, costume shortages, and rekindled uncertainty.

And we were tired.

The first day of January classes we already had a few teachers out. We were strategically placing substitutes, but the prospective roster of instructors and substitutes was whittling down. There was a chance we'd have to consider combining or canceling classes, something we'd never had to do in thirteen years of operation. I try to practice grounding myself in the calm, but I could feel my stress and tension rising.

Then, out of the blue, one of our former instructors reached out. She was home for the entire month of January and was able to jump in and help as needed. I am a strong believer in signs, and this was a sign that, once again, we'd make it through another challenging period.

At the end of the month, I received a note that said:

> *Thank you so much for the community that you have cultivated at Stage Door Dance. Your students and staff alike are such wonderful, beautiful people that constantly make me feel at home and part of a family. What you have created is so inspiring and irreplaceable. Thank you for building a studio and a community that has been a constant for me ever since I started working there. Through so many ups and downs in my personal life, I always knew that when I went to teach at Stage Door,*

everything was left outside and I could dance it out with
my students in an incredibly positive environment. Stage
Door was truly an answer to prayer and a beautiful
unexpected blessing from God.

Whenever I'm at a point where I need a reminder about the importance of this life and my work, it shows up.

Persistence keeps us pushing.

I was once told that if it can be fixed by money, it is a solvable problem. Money can be re-earned.

I would remind myself of this with every student drop during the pandemic. When our monthly revenue was the lowest it had ever been, I shifted my focus from recruiting new students to expanding the services of the clients we had and the support they needed. I never, in a million years, imagined running a remote school. But, because the need was there, we did it.

If you think about the power of money, it's true.

Money cannot buy time.

Money cannot indefinitely keep the people we love and care about with us.

Money cannot bring happiness.

On March 2, 2021, I received a reminder of this message. I was sitting in my office and having my first chat with my TEDx speech curator. Zoom wasn't working on my desktop, so I switched the call to the Zoom app on my phone. A few minutes into the call, my husband, John, tried calling me. I declined the call.

Earlier in the day, I had asked him to pull some of Laila's halter dresses for a pillow commissioned for the nursery. I figured he was calling to update me on the items he found. He

knew I had an important meeting, and I planned to call him back when it was over. Then he called again. This time, my gut could sense the urgency, so I answered.

John was on the other line, but I could tell something was wrong. Shaken, he said, "A delivery truck hit me and knocked me off my bike. I need you to know that I'm okay." Shaken and numb, I rushed out of my office, jumped in my car, and headed to the site. I was thirty-two weeks pregnant and kept telling myself to stay calm. On loop, I'd remind myself: *"He called. You heard him. He's okay."*

The thought of losing him on the brink of us building a family together was unbearable.

During the twelve-mile drive from my office to the crash site, I kept thinking about my mom receiving the news about my dad. He was riding in a truck that swerved to avoid a car on a bridge in March of 1987. While my dad was alive at the scene, the nearest hospital was too far away to save him. Both the driver of the truck and my dad died. At that moment, our short-lived nuclear family was shattered. My mom's goodbye was identifying his body at the hospital.

Nearly thirty-five years later, I was feeling fortunate and blessed that our family was not shattered on that March day. The days after the crash were tough and a little blurry. At first, simple things like walking weren't easy. Everything paused with baby preparation and the nursery renovating. But the real elephant in the room was the fact that a passion and a life could have been gone without any notice. Everything else would get back on track.

And, with determination as a core value of our partnership,

it did. My baby showers were the weekend after the crash. I thought it would be hard to celebrate in the aftermath of this trauma, but both events, a star-themed drive-through event at Stage Door Dance and a Broadway-themed Zoom baby shower show for our closest friends, were both healing celebrations that reminded us of how loved our child and our family would be.

I wasn't sure John would be able to make it, but he was able to make it to the Zoom shower. He even performed, as he had written a parody of the song "Shallow," sung from our dog Elvis's point of view. There wasn't a dry eye in the individual Zoom squares.

Two weeks later, we were in Kiawah Island and John was getting back on a bike. Now, he's participating in cycling races. We don't take a moment of this beautiful life for granted, and I am attuned to the many blessings of my life.

The potential for life to radically change in a moment is an unspoken truth with universal impact.

One move and one action can rip away life as we know it.

This particular incident combined with upcoming childbirth propelled me into a frenzy of legacy planning. Could the businesses function if I was incapacitated? Did we have documents in place that would keep everything operating at a level of excellence? We didn't, and we needed to get things in order. And we needed to do it fast.

I whipped together a "doomsday document" that detailed the majority of our day-to-day operations. We invested in software platforms that would help us stay connected and in communication. This was a tough exercise, but in doing it, I realized the strength of our team.

While I didn't want to step away from leading what I love, I realized that I could delegate more. This would enable me to simultaneously invest in the growth of my family and my companies, while giving others the opportunity to contribute their talents in a more meaningful capacity.

Trauma and crisis connects us in a profound way. It shatters routine and forces us to immediately address the hard questions. We see things differently, and we question the "what ifs?"

As we process the road bumps of life, it is important to share, reflect, and seek professional help, when needed. We should never feel as though our problems are too insignificant or that we are too strong to seek and reap the benefits of mental healthcare.

Mental health is of equal importance to physical health. I've experienced a lot in my life. In differing parts of my journey, I have sought professional help. You can do everything "right" and life will still position you with the need for greater help. There's no shame in taking care of you, because, in taking care of yourself, you're taking care of anyone else who receives your love, talents, and presence.

If I am not functioning at my fullest capacity in regard to my spiritual, emotional, and mental health, I know I cannot be an optimal leader. I want to be there for my family and my businesses. Taking care of myself is a step towards achieving that goal.

There's also a beautiful opportunity for a piece of our wellness to be practicing and living a life within the arts. The arts diffuse negative emotion and infuse positive emotion. The creativity of this sphere allows opportunity to bloom in crisis. Whether you're taking a dance class, writing, putting together a costume, or making a craft, the process of creating is cathartic in itself.

As we put forth the effort for our self-development, we must acknowledge the greatest gift we can give ourselves is the opportunity to intentionally choose peace. That doesn't mean we forget. It simply means we allow the shrapnel that breaks our heart the equal power to heal it.

In February 2020, I spoke at a Women's Power Networking luncheon. It was small and intimate, but I was inspired by the presence and attentiveness of the women within the room. I had a script to follow, but that day (and many days, honestly), I felt compelled to veer away from the scripted words and speak from my heart. It was one of the first times I was so publicly vulnerable about my journey.

At the end, a woman approached me and very honestly said, "You remind me of Esther in the Bible. Keep up the good work."

My biblical knowledge is a little rusty, and I didn't immediately understand the context of the compliment. I thanked her for sharing the comparison and looked it up as soon as I was in my car. I was moved by what I discovered.

Esther was a servant leader, using her position for the good of her people. She evolved into an influential, authentic, and powerful female historical figure by placing the Jews above herself.

There's a lot to unpack in the story, but during this pandemic period of time where crisis became the norm, I leaned into her path and thought about how to best lead those around me.

I had been through previous tests and felt prepared for this paramount time that could make or break everything I'd built.

Esther 4:14 contains a powerful scripture: "You have come to your position for such a time as this."

Esther's story reminded me:

1. Ordinary people can do extraordinary things.

2. We can use faith to fight our fears.

3. The past doesn't dictate our future.

4. Patience is a necessity.

5. Loving others is our most powerful tool.

6. Our leadership and strength can make an impact.

As the days turned into months and the months turned into years, the pandemic reminded me that change is constant. Triage is the assessment. With intent, joy can be the outcome.

During the dark days, I became obsessed with the idea of rainbows as a symbolism of brightness, representing the hope of calm and clarity after the storm.

Would I say that calm, clarity, and brightness has arrived? No, I would not. But, I have learned that if you look for it and create it, you will find it.

As Martha Washington said, "I am still determined to be cheerful and happy in whatever situation I may be...for I have also learned that the greater part of our happiness or misery depends upon our dispositions, and not upon our circumstances."

In the game of life, if I'm lucky and time is on my side, I'm cruising towards the end of act one or intermission. There's a lot that's been done, but we still have so much to do.

Many think situations are a clear-cut "win" or "lose," but that's not the case. Instead, I think life is more about how we move, the plays we make, and the way we choose to respond.

Those movements enable us to win or lose situations, and the sum of those creates our legacy.

Becoming a mother has made me hyper-aware of this journey. This new role is without a doubt the greatest, most paramount position of my life. Every second is equally terrifying and thrilling as I see the world from this new perspective. My heart swells with love in ways that I've never known, and it is my ultimate goal to get this right. There are times when I'll look at my sleeping son, and I'll tearfully think, "I hope the world is kinder and easier on you than it has been on me."

But getting it right doesn't mean getting it perfect. It means learning together and growing as we go. I see my son's tenacity, and I know my job isn't to ask the world to be easier on him. Instead, my role is to prepare him for whatever comes his way. The horrible exists and will continue to disrupt, interrupt, and challenge us in varying forms.

How do we take the circumstances we are given and turn them into a life that's impactful, purposeful, and meaningful?

That book I mentioned at the beginning?

What if we turned it into Alexander and the Terrible, Horrible, No Good, Very Bad Day That Turned Out to Be a Huge Learning Opportunity?

At the end of our rewrite, Mom can say some days are like that, but Mom can also say:

- We learn.

- We grow.

- We become better prepared.

- We improve our adaptability, resilience, and perseverance.

- We can embrace the coexistence of:
- Growth and Mistakes
- Anxiety and Confidence
- Accountability and Self-Forgiveness
- Learning and Unlearning

We take the lemons and we make the sweetest, sugariest lemonade you can imagine.

When I'm out walking, I'm moved by every three-legged dog I see. They're giddy, grateful for the day, and enjoying their walk even if they have to work harder than the dog with four legs. Their light shines bright because they elevate beyond their circumstances instead of wallowing in them.

There's no reward in playing the victim or wading in the woes of what could have or should have been. Instead, let's take the day as it comes, live in it, handle it, and continue to ascend. Let's live a life where we handle the horrible, but in the horrible, we generate a life of happiness. There's balance, beauty, perseverance, and hope.

And next to that hope, there's art.

The Institute of Child Psychology suggests that every child is an artist until they are told they are not to be.

> *"Before they speak, they sing. Before they write, they paint. As soon as they stand, they dance. Art is the basis of human experience."*
>
> —AUTHOR UNKNOWN

Recently, I returned to the Durham Performing Arts Center.

I took my aunt to see *Hamilton*. As we exited the show, I saw two of our dancers, wearing Hamilton hoodies. They immediately ran up, still buzzing from the excitement. As I asked them if they enjoyed it, they immediately responded, "It really made me feel something."

At that moment, I was reminded of the power of everything I've written in these pages.

If we intentionally combine all these elements, we can create a true win in the game of life, leading us to a legacy where a raucous standing ovation is deserved—for you and for the future generations that are waiting in the wings and watching.

EPILOGUE

I COULD NOT end this book without noting that sometimes the bad things that happen in our lives put us directly on the path to the best things that will ever happen to us.

I'll leave you with this story.

In late summer 2016, John, as my friend, told me that I had to see this new Damien Chazelle movie that was coming out during the holiday season. He said it was "a movie for dreamers" and that it was "made for me." It starred Ryan Gosling and Emma Stone and struck me as a tip of the hat to old Hollywood movie musicals. From the minute he tagged me in a Facebook post featuring the trailer, I couldn't wait to see it.

At the time, our paths were on two very different trajectories, and we weren't seeing or speaking to each other very frequently. Still, I was honored he thought of me.

In December of 2016, I saw the movie *La La Land* at the South Street Seaport in NYC. At the end of the film, there is an epilogue that summarizes a montage of choices from the hypothetical point of view of the protagonist's life. The epilogue

ponders what if her life had been lived differently. What if she made different decisions about love, career, life, and family? It's hauntingly beautiful, and somewhat sorrowful, depending on where you are at in your life.

When the movie first came out, I watched it multiple times in the movie theater, several times on a Disney Cruise, and too many times to count once it was available for home viewing. Each time, it would hit a little closer to home. It would crack away at the safe, comfortable life I was living versus the passionate life I desperately wanted to live.

This prompted endings that became beginnings.

It instilled a deeper sense of empathy and humility.

It allowed me to experience the quiet depths of darkness and the exuberant joyful moments of happiness.

It gave me the gift of passionate, true love, which led to an equally incredible gift of being a mom.

The course of life is constant and steady. We can stick with what we know and what's easy, but I will argue that there will be a minimum of one point in your life where you are going to have to make some radically uncomfortable moves to maintain truth in your life journey.

You may be ostracized or condemned for those choices. People may not understand why you make the decisions you have to make.

But the cost of not following your heart is spending the rest of your life wishing you had.

When it comes to your story as a piece of art:

- You paint the picture.
- You choreograph the dance.

- You direct the show.

Where you are a year from now is a reflection of the choices you make right this second and every second thereafter.

The following quote from *the Curious Case of Benjamin Button* is a powerful one. It is one that I've read many times as I've pondered my path. I hope it will inspire you in the way it has inspired me.

> *For what it's worth...it's never too late, or in my case too early, to be whoever you want to be. There's no time limit. Start whenever you want. You can change or stay the same. There are no rules to this thing. We can make the best or the worst of it. I hope you make the best of it. I hope you see things that startle you. I hope you feel things you've never felt before. I hope you meet people who have a different point of view. I hope you live a life you're proud of, and if you're not, I hope you have the courage to start over again.*

I've reflected a lot on my choices, changes, leadership, and consequences over the years. There are times I've gotten it right, times I've gotten it wrong, and times where I've simply given it my best. But I tried. I tried with all of my might, in spite of the horrible, and will continue to do so.

In his *The Wedding Singer* playbill bio, John thanked me for my "incomparable support and infectious attitude that made him feel as if he could burst through a concrete wall." I wasn't even trying to make him feel that way. It just happened because we brought out the best in each other.

At that moment, I recognized the power of surrounding

yourself with people, places, and projects that set your soul on fire. When I saw it play out on screen in *La La Land*, I realized it.

Aspirational humanity is how we can collectively improve the world, and I'm ready, energized, and committed to doing my part, even when it is hard. I hope you are, too.

Cheers to the dreamers and doers of the world, especially the ones who persevere during difficult times.

CPSIA information can be obtained
at www.ICGtesting.com
Printed in the USA
BVHW041215030922
646120BV00003B/4/J